IMAGES
of America

HISTORIC STAGE ROUTES
OF SAN DIEGO COUNTY

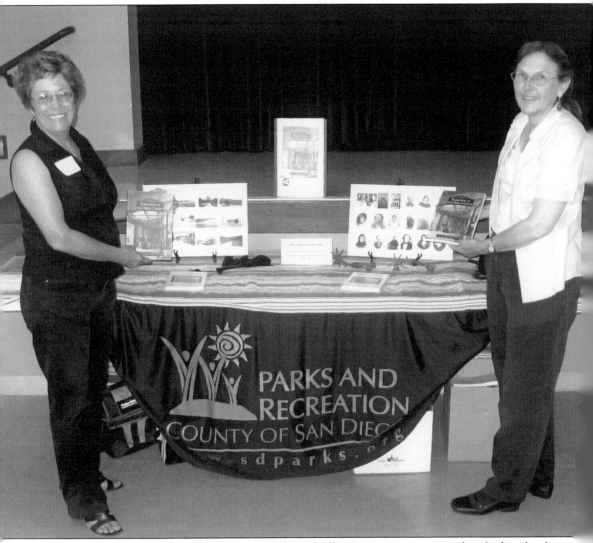

Authors Lynne Newell (Christenson), at left, and Ellen L. Sweet are pictured with their book *Ranchos of San Diego County*, a publication sponsored by the County of San Diego Department of Parks and Recreation. (Melvin M. Sweet.)

ON THE COVER: Taken in 1904 by San Diego photographer John E. Slocum, this image of Vallecito Stage Station shows the station and an outbuilding. The visitors were also photographed at Carrizo Creek Station (see page 51). (San Diego History Center.)

IMAGES
of America

HISTORIC STAGE ROUTES OF SAN DIEGO COUNTY

Ellen L. Sweet and Lynne Newell

ARCADIA
PUBLISHING

Published by Arcadia Publishing
Charleston, South Carolina

Printed in the United States of America

Library of Congress Control Number: 2010939077

For all general information, please contact Arcadia Publishing:
Telephone 843-853-2070
Fax 843-853-0044
E-mail sales@arcadiapublishing.com
For customer service and orders:
Toll-Free 1-888-313-2665

Visit us on the Internet at www.arcadiapublishing.com

*This book is dedicated to the memory of Louis and
Dolores Strahlmann, local historians and preservationists,
who were fascinated with the history of staging.*

CONTENTS

ACKNOWLEDGMENTS

The authors thank the County of San Diego Department of Parks and Recreation and the San Diego County Parks Society for sponsoring this publication.

Photographs used in this book are from the County of San Diego Department of Parks and Recreation History Center or the authors' personal collection unless otherwise noted. We appreciate the help of Chris Travers, Carol Myers, and Jane Kenealy of the San Diego History Center (SDHC); Sue Wade of Begole Archaeological Research Center, Colorado Desert District, California State Parks (CADPR-CDD-BARC) for sharing research and photographs; and Bruce Coons of Save Our Heritage Organisation (SOHO) for giving us access to the Copley Press–Richard Pourade collection.

Other photographs used in the book are from the Anaheim Public Library (Anaheim); the Library of Congress (LC); the California State Library (CSL); the University of Oklahoma (UOK); California State Parks, San Diego Coast District (CADPR-SDCD); the California Historical Society collection at USC (CHS collection, USC); the Braun Research Library (Braun), and the Southwest Museum of the American Indian (Southwest), Autry National Center of the American West. The watercolor of Vallecito by Seth Eastman was photographed by Erik Gould, courtesy of the Museum of Art, Rhode Island School of Design.

Individuals who generously shared their photographs and research with us include Joe Jacobs (JJ), Alana and Bruce Coons (ABC), Marie Clark Walker (MCW), Phil Ewing (PE), Kathy Feigel (KF), Ed Pollock, Bonnie Bruce, Susan Walter, Stephen Van Wormer, Jan Dye, Fred Grand, Buzz and Dorothy Mushet, Pamela Miller, Carol Taylor, and Richard Miller. We gratefully thank James A. Bradshaw (JAB) for sharing his Albert W. Shattuck photograph album.

We are extremely grateful to Melvin M. Sweet (MMS) for his photographs and his expertise in preparing all the photographs used in this book; Donald E. Newell (DEN) for his photography; Barbara Burroughs for her assistance; George Hanson, Grace Aspiras, Bill Woolman, and the board of the San Diego County Parks Society for their financial support; and Brian Albright, Cailin Hunsacker, and Cheryl Wegner of the County of San Diego Department of Parks and Recreation for their support and encouragement.

INTRODUCTION

Hollywood movies, Western novels, and tourist attractions romanticize and popularize 1800s stagecoach travel. Some information about local stage travel is true, and some of it is myth. But San Diego County still has substantial traces of the first overland mail routes, the Birch and the Butterfield. Three stage stations still exist: Vallecito, which has been restored (and its restoration is a story in itself); Warner-Carrillo, which is being restored; and Oak Grove, which remains in private hands. Traces of the old emigrant and stage route can still be seen from overlooks of the fragile desert and along rocks where rust and wheels tracks have left marks. Descendants of some staging families still relate their proud family history. Old Town San Diego's Plaza served as the terminus of Birch's San Antonio–San Diego Mail Line. Other stage routes in San Diego County can still boast a stage station. The Coast Line's station at Las Flores Ranch House on Camp Pendleton and Seeley's Cosmopolitan Hotel in Old Town are newly restored. This book presents the San Diego story of the stage, both past and present, in photographs and images.

The Gold Rush, western expansion, and California statehood presented the need for better communication with the rest of the United States. Localized stage travel in the mining areas of Northern California started early. The expansion of stage lines to overland routes with the Birch line in 1857 and the Butterfield a year later served to bind the nation together. San Diego was one end point of that first overland route. While the Butterfield did not go to San Diego itself, it did travel through San Diego's backcountry.

James Birch and John Butterfield were staging pioneers. Birch was only 30 years old when he started his overland San Antonio–San Diego Mail Line. His untimely death put a stop to a brilliant career, although his stage line continued to operate. John Butterfield, on the other hand, was close to retirement age in 1858 when the Butterfield Overland Mail started running stages between St. Louis and San Francisco.

The difficulties encountered and the enormity of the task of putting these routes in operation cannot be overstated. Given the large outlay of money for stage stations, barns, stables, corrals, coaches, drivers, employees, mules and horses, supplies, road improvements, wells, and so forth, the stage was never a moneymaking enterprise. Few people actually rode the stage across the country; they usually preferred to ride shorter distances. These stage and mail lines did not accomplish as much as their promoters hoped for, mainly due to the interference of the Civil War. But they did serve to keep communications flowing. Mail and newspapers were carried each way. Isolated communities became less isolated. Miners and emigrants coming overland by wagon train were able to obtain reliable information about the road, water, camping, grass, wood, and hazards from the stage conductor. The line did help to open up and develop the neighboring Arizona Territory.

During the Civil War years, there was little stage travel; some coast travel was still available. Starting in 1869, other stage lines appeared, mainly to Fort Yuma and the Julian mines. Stage men like Albert Seeley, John Capron, Frank Frary, and Joseph Foster ran local stages. Some stages were short-lived due to inexperience, competition, rough roads, flooding, or other reasons, and

lines operated in other areas throughout the county and down into Baja California. Some were still operating into the early 1900s in the outlying areas.

In the late 1920s and 1930s, efforts were made to preserve the traces of these pioneering transportation enterprises. Dr. Louis Strahlmann and his wife, Dolores, became enthusiastic supporters and historians of the Birch line. As Dolores stated in a letter to a member of the Giddings family on July 2, 1938, "I am happy that you are glad about our work on this old stage road. This has been my pet hobby for almost ten years and has, indeed, become almost an obsession with me." Through their direct efforts in uniting politicians, landowners, chambers of commerce, and the general public, the Vallecito Stage Station was restored, and the land became a San Diego County park. The Strahlmanns worked with members of the staging Banning family to learn more about their family business. George Hugh Banning had traced the Butterfield line by automobile in 1929, and he shared his information and photographs with the Strahlmanns.

These citizen preservationists worked hard to record, photograph, interview, document, verify, and search out everything they could about the early stage lines. Their goals were to preserve stage stations and to mark the trails as well as to collect items for a museum. It is through their efforts that the story of the Lassator-Mulkins family of Vallecito and the 1934 restoration work of Vallecito can be shown in this book. If the Strahlmanns were here today, they would invite you to read the stories, look at the photographs, go out and experience the stage route yourself, and then find ways to help promote and preserve our staging history.

One

SAN ANTONIO–SAN DIEGO MAIL LINE

James E. Birch, a wealthy businessman who successfully operated stage lines in Northern California, saw the need for a regular transcontinental overland mail and stage route. He made trips to Washington, DC, to promote his vision. In August 1856, a postal route bill was enacted, establishing a stage road from San Diego to San Antonio with connections to the existing routes already running to New Orleans, St. Louis, and points on the Atlantic seaboard. The contract for Route 8076 was awarded to Birch in June 1857, with the contract set to begin July 1.

The line to San Diego was considered an all-weather route. However, large stretches of desert had to be crossed, and water sources were always a concern. When Birch's superintendent laid out the route, he placed some of the road south of the California-Mexico border following a military and emigrant route determined by wells. Another problem was the road into San Diego. The fastest way to bring the mail into San Diego was a steep mule-only trail from the desert across the mountains. Coaches traversed a longer route from the desert to Warner-Carrillo and then south to San Diego through Santa Ysabel.

Birch and his staff organized the San Antonio–San Diego Mail in record time. Stage stations were established at 20- to 30-mile intervals. Coaches were purchased, and some 400 animals were distributed as well as the necessary feed, provisions, and supplies. On July 9, 1857, the stages rolled from both ends. The first trips took longer than the planned 30 days, but 21-day service was finally established.

The Birch line was welcomed by San Diegans who felt that the mail route would very likely determine the route for the proposed transcontinental railway. The San Antonio–San Diego Mail ran from 1857 to 1861, predating the famous Butterfield stage by one year. The line was discontinued because of the Civil War and the political necessity of operating the mails on a more central route during times of strong sectional rivalry.

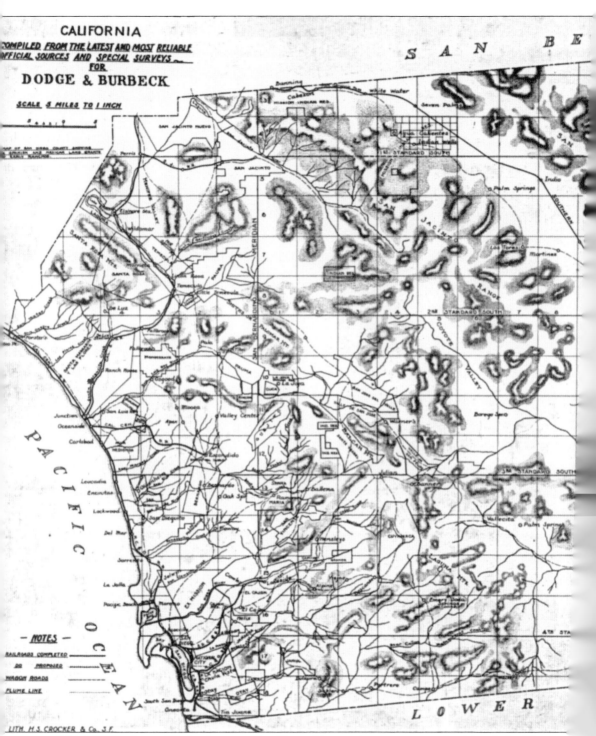

This 1889 Dodge and Burbeck map of San Diego County shows wagon roads with a dashed line. Many of the early desert stage stations like Indian Wells and Vallecito are shown on the route from Yuma on the Colorado River going westward, first looping down below the California-Mexico

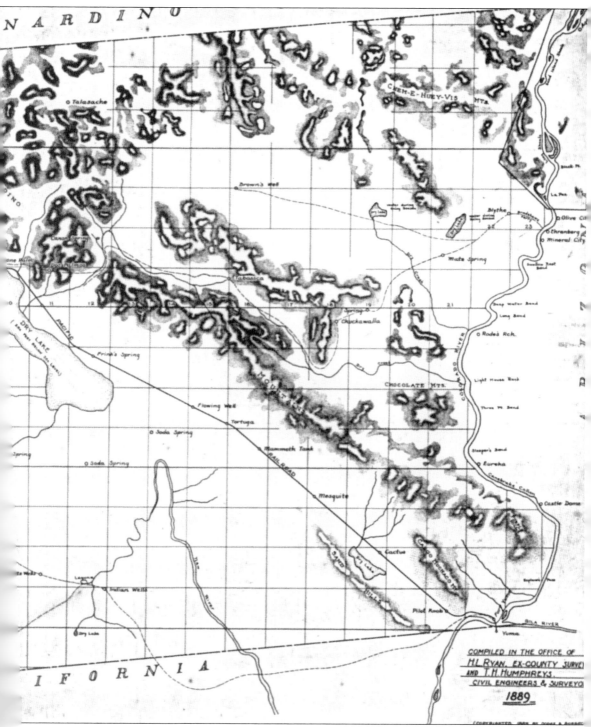

border. When the first transcontinental mail line began in 1857, San Diego County covered the area that was shown here—14,800 square miles. In 1857, the county included what are now Imperial and Riverside Counties.

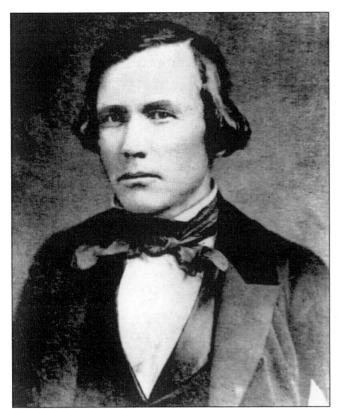

The first scheduled overland mail carried from California to the Atlantic coast was dispatched in April 1848 by the military governor under the care of Christopher "Kit" Carson. It probably contained the first news of the discovery of gold. During the early 1850s before the stages, mail to and from the East was carried by steamers and took three to six months.

James E. Birch (1827–1857), who was to become one of the most successful stage contractors in the West, arrived in the mining area of California in 1849. This young, gifted businessman started running wagons and stages in the gold country that carried miners and their equipment from Sacramento to the diggings. He saw the need for a transcontinental route and organized the San Antonio–San Diego Mail in 1857.

This painting of a stage from the California Stage Company hung in the Birch home in Swansea, Massachusetts. James Birch consolidated some 20 lines running out of the Sacramento depot to the various mines and cities of California and formed the California Stage Company in January 1854. The company had capital of $1 million, and James E. Birch was its president.

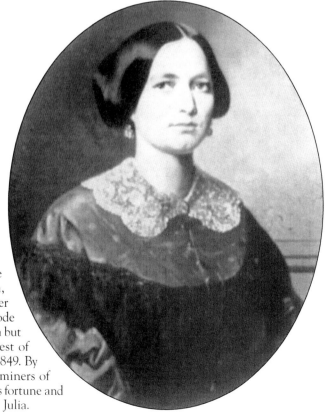

Julia Ann Briggs Chace (about 1828–1871) of Swansea, Massachusetts, was the half sister of James Birch's employer in Rhode Island. Birch fell in love with Julia but set out to California with the rest of the adventurers in the spring of 1849. By providing transportation to the miners of California, he was able to make his fortune and return to Massachusetts to marry Julia.

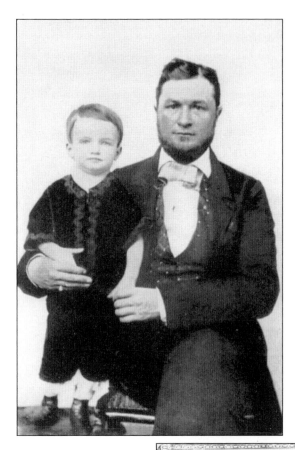

Frank Shaw Stevens (1827–1898) met James Birch and Julia Chace in Rhode Island, where he worked with Birch in a livery stable. Partnering with Birch, he traveled with him to the California gold fields. Stevens (right) is shown here with Birch's young son Frank Stevens Birch, born in 1856 and named to honor his father's friend. When Birch died tragically (see page 34), Stevens married Julia and cared for her son.

This 1854 advertisement for the California Stage Company lists James Birch as president and Frank Shaw Stevens as vice president of the consolidated stage lines running out of Sacramento. Concord coaches ran to Marysville, Shasta, Placerville, Coloma, Sonora, Drytown, Auburn, Rough and Ready, Grass Valley, and other mining areas. Running stage lines in Northern California prepared Birch for organizing the first transcontinental mail.

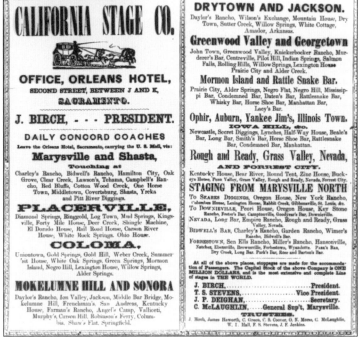

In 1857, when James Birch received a contract to carry the mail from San Antonio to San Diego, he hired John James Giddings (1821–1861) to survey and lay out the mail route. Giddings is shown in this 1848 wedding picture with his bride, Margaret Matilda Sloan. Tragically, John Giddings was murdered in Arizona while on a route-inspection tour.

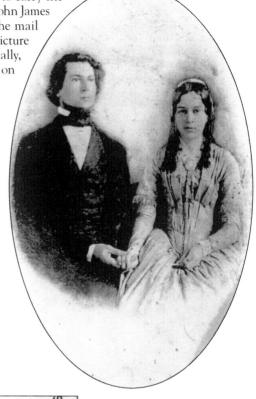

James Birch registered these brands with the San Diego County Recorder in 1857. The top brand, registered in the name of Birch, represented the US Mail. The second, a B, was the brand of the San Antonio–San Diego Mail Company. Large numbers of mules, horses, and livestock were necessary for the running of the stages. Brands helped clarify ownership.

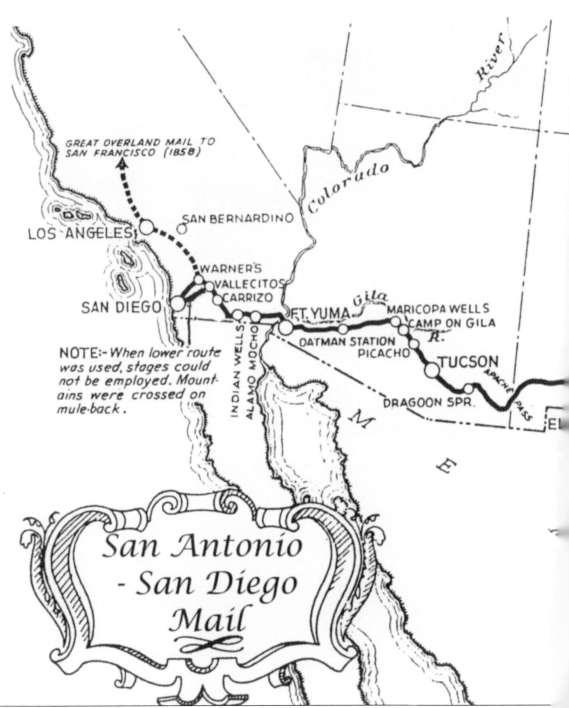

The San Antonio–San Diego Mail was considered the first transcontinental mail and operated from 1857 to 1861. It ran across San Diego County, through Warner-Carrillo Ranch, Vallecito, and Carrizo Creek to Fort Yuma on the California side of the Colorado River, crossed the river,

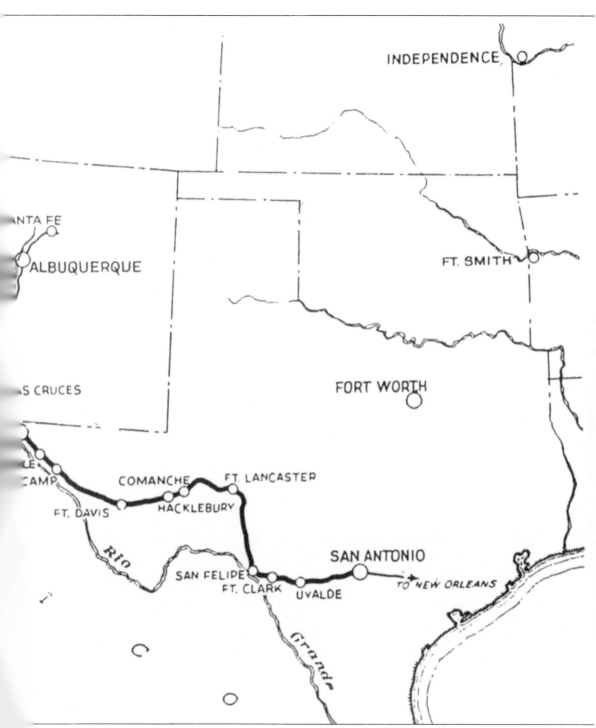

passed through Tucson, El Paso, and went on to San Antonio, where it connected to rail, stage, and steamer lines to the East.

brings report of their success, while passengers are, all the while, taking our line to Arizona; our stations afford stopping places, and our agents information to all who prefer their own mode of conveyance; such travelers are numerous.

"The newly appointed consul for Guyamas takes our stage as far as Tucson, starting from San Antonio, Texas.

"Our line is already forming the basis of a new State, rich in minerals, half way between Texas and California."

Table of distances, and from one watering-place to another from starting point.

From San Antonio to Leon river,	6.53
From Leon to Castroville, " Medina " river,	18
From Castroville to Dharris " Saco " river,	25.28
From Dharris to Ranchero creek,	8.38
From Ranchero creek to Sabinal creek,	3.94
From Sabinal creek to Camanche creek,	5
From Camanche creek to Rio Frio,	8.46
From Rio Frio to Head of Leona " Uvalde "	6.08
From Uvalde to Nueces,	9.04
From Nueces to Turkey creek,	10.27
From Turkey creek to Elm creek,	15.23
From Elm creek to Las Moras river, Fort Clarke,	7.13
	——— 123.34
From Fort Clarke to Piedra Pinto,	7
From Piedra Pinto to Maverick creek,	8.86
From Maverick creek to San Felipe,	12.61
From San Felipe to first crossing of San Pedro or Devil's river,	10.22
From First Crossing to Painted Caves,	2.54
From Painted Caves to California Spring,	15.73
From California Spring to Willow Spring,	2
From Willow Spring to Fort Hudson, or second crossing of San Pedro or Devil's river,	16.39
	——— 75.35
From Fort Hudson to Head of San Pedro or Devil's river,	19.50
From Head of river to Howard Springs,	44
From Howard Springs to Live Oak creek,	30.44
From Live Oak creek to Fort Lancaster,	3
	——— 96.94
From Fort Lancaster to Pecos,	4.29
From Pecos Crossing to Pecos Spring,	6
From Pecos Spring to Leaving of Pecos,	32.26
From Leaving of Pecos to Arroyo Escondido,	16.26
From Arroyo Escondido to Escondido Spring,	8.58
From Escondido Spring to Camanche Spring,	19.40
From Camanche Spring to Leon Hole,	8.88
From Leon Hole to Hackberry pond,	11
From Hackberry pond to Limpia creek,	32
From Limpia creek to Fort Davis,	18.86
	——— 157.53
From Fort Davis to Point of Rocks,	10
From Point of Rocks to Barree Springs,	8.42
From Barree Springs to Deadman's Hole,	13.58
From Deadman's Hole to Van Horn's Well's	32.83
From Van Horn's Wells to Eagle Springs	19.74
From Eagle Springs to first camp on Rio Grande	31.42
From first camp on Rio Grande to Birchville	35
	——— 150.99
From Birchville to San Eleazario	24.80
From San Eleazario to Socorro	5.45
From Socorro to Isletta	3.10
From Isletta to El Paso	14.14
	——— 47.49
From El Paso to Cottonwood	22
From Cottonwood to Fort Fillmore	22
From Fort Fillmore to La Mesilla	6

The mail contract for Route 8076, San Antonio to San Diego, was awarded to James Birch by the postmaster general. The contract was to run for four years with an annual payment of $149,800. Service was semimonthly, with 30 days allotted for the trip each way. Stops along the route, including distances, are listed in these two pages (this and the following image) of the 1859 *Texas Almanac*. No single stagecoach, driver, or mule traveled the entire route. People, equipment, and livestock were changed at major stops along the way.

From La Mesilla to Cook's Spring	65
From Cook's Spring to Rio Mimbres	18
From Rio Mimbres to Ojo La Vaca	17
From Ojo La Vaca to Ojo de Ynez	10
From Ojo de Ynez to Peloncilla	34
From Peloncilla to Rio Saur or San Domingo	18
From Rio Saur to Apache Springs	23
From Apache Springs to Dos Cabesas Springs	9
From Dos Cabesas Springs to Dragon Springs	26
From Dragon Springs to mouth of Quercos canon	18
From Mouth of Quercos canon to San Pedro crossing	6
From San Pedro to Cienega	20
From Cienega to Cienega creek	13
From Cienega creek to Mission San Xavier	20
From Mission to Tucson	8
	—— 305
From Tucson to Pico Chico mountain	5
From Pico Chico to first camp on Gila	35
From first camp on Gila to Maricopa Wells	29
	—— 99
From Maricopa Wells to Tezotal, across Jornada	40
From Tezotal to Ten-mile camp	10
From Ten-mile camp to Murderer's Grave	8
From Murderer's Grave to Oatman's Flat, 1st crossing of Gila	15
From Oatman's Flat to 2d crossing of Gila	25
From 2d crossing of Gila to Peterman's station	32
From Peterman's station to Antelope Peak	20
From Antelope Peak to Little Corral	24
From Little Corral to Fort Yuma	16
	—— 190
From Fort Yuma to Pilot Knob	7
From Pilot Knob to Cook's Wells	13
From Cook's Wells to Alamo Mucho	21.94
From Alamo Mucho to Indian Wells	20.94
From Indian Wells to Carissa creek	32.24
	—— 95.12
From Carissa creek to Vallecito	18
From Vallecito to Lassator's ranch	18
From Lassator's ranch to Julian's ranch	7
From Julian's ranch to Williams' ranch	7
From Williams' ranch to Ames' ranch	14
From Ames' ranch to Mission San Diego	16
From Mission to San Diego	5
	—— 85

Recapitulation.

San Antonio to Fort Clarke	123.34
Fort Clarke to Fort Hudson	75.35
Fort Hudson to Fort Lancaster	96.94
Fort Lancaster to Fort Davis	157.53
Fort Davis to Birchville	150 99
Birchville to El Paso	47.49
	—— 651.64
El Paso to La Mesilla	50
La Mesilla to Tucson	305
Tucson to Maricopa	99
Maricopa to Fort Yuma	190
Fort Yuma to Carissa	95.12
Carissa to San Diego	85
San Antonio to San Diego	1,475.76

This continuation page of Route 8076 from the *Texas Almanac* shows the total distance traveled as 1,475.76 miles. The portion of the route in San Diego County was 180 miles. From Fort Yuma westward, the major stops listed are Pilot Knob, Alamo Mocho, Carrizo Creek, Vallecito, Lassator's ranch, Julian Sandoval's ranch, Williams' ranch, Ames' ranch, Mission San Diego, and Old Town San Diego.

The Birch Mail used celerity or mud wagons on its route across the county. Because of the terrain, a lighter, simpler coach was needed. The mud wagon's sides and ends were straight, and the roof was usually made of heavy canvas stretched over the framework. Canvas side curtains could be rolled up and fastened. The thoroughbraces were placed directly over the axle bolsters.

In contrast to the mud wagon, the Concord wagon was heavier, more ornate, and had a suspension that gave it a "teacup in a saucer" appearance. Concord coaches were used later on the Butterfield overland route and on Seeley's Coast Line.

SAN ANTONIO AND SAN DIEGO

MAIL LINE.

THE Proprietors of this Line, having completed their arrangements with the Western Texas Stage Company, and with the Texas Steamship Company, are now ticketing passengers through from El Paso to New Orleans.

Time as quick and fare as low as by any competing line.

As a winter route ours possesses advantages over all others.

For further particulars, apply to Messrs. Freeman & Co.

I. C. WOODS, Superintendent,

no13 tf S. A. and S. D. Mail Line.

This advertisement for the San Antonio–San Diego Mail ran in the *San Francisco Herald*. It was signed by Isaiah C. Woods (1825–1880), who was the line superintendent. Woods set up the mail line for Birch. His 1858 report to the postmaster general chronicled his journey over the line and back. It was Woods who hired men and stations, purchased coaches, mules, supplies, and fittings, and commenced the actual operations.

Another advertisement for the mail line shows ticket prices. Fare to San Diego was $190. Note the statement that the passengers and mail traveled in coaches drawn by six mules, except for a 100-mile section on mule-back. It was this statement plus the reputation of Woods, due to the crash of his Adams Express Company, and rivalry between cities that led to the derogatory term "Jackass Mail."

OVERLAND TO THE PACIFIC.

The San Antonio and San Diego Mail-Line.

This Line, which has been in successful operation since July, 1857, is ticketing PASSENGERS through to San Diego and San Francisco, and also to all intermediate stations. Passengers and Express matter forwarded in NEW COACHES, drawn by six mules, over the entire length of our Line, excepting the Colorado Desert of one hundred miles, which we cross on mule-back. Passengers GUARANTEED in their tickets to ride in Coaches, excepting the one hundred miles above stated.

Passengers ticketed through, from NEW-ORLEANS, to the following points, via SAN ANTONIO:

To Fort Clark,	Fare, $52.	To Fort Bliss,	Fare, $100.
" Hudson,	" 60.	" La Mesilla,	" 105.
" Port Lancaster,	" 70.	" Fort Fillmore,	" 105.
" Davis,	" 90.	" Tucson,	" 135.
" Quitman,	" 100.	" Fort Yuma,	" 162.
" Birchville,	" 100.	" San Diego,	" 190.
" San Elizario,	" 100.	" Los Angelos,	" 190.
" El Paso,	" 100.	" San Francisco,	" 200.

The Coaches of our Line leave semi-monthly from each end, on the 9th and 24th of each month, at 6 o'clock A.M.

An armed escort travels through the Indian country with each mail train, for the protection of the mails and passengers.

ADVERTISEMENT OF AN OVERLAND STAGE LINE

Mark Twain paid $150 for a ticket from Missouri to Nevada by another line.

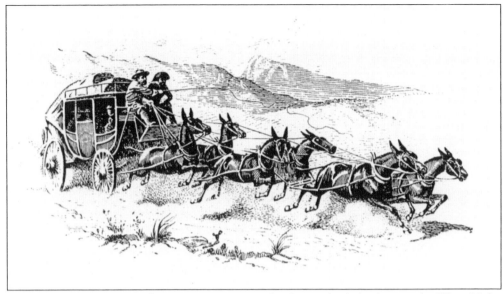

This sketch of six mules pulling a stage is a reminder that mules helped move the West. Mules were used by the Army to accomplish almost impossible tasks: climbing steep mountains, bearing huge packs, living on grass, and averaging more than 30 miles daily. Isaiah Woods used them for Birch's stagecoaches. In his report, Woods wrote of the difficulty in purchasing suitable mules for the task.

Each man purposing to go through should provide himself with a Sharp's rifle, (not carbine,) with accoutrements, and one hundred cartridges, a navy sized Colt's revolver and two pounds of balls; a belt and holster, knife and sheath; a pair of thick boots and woollen pants, half a dozen pairs thick cotton socks, three under shirts, three brown linen ditto, three woollen overshirts, a wide-awake hat, a cheap sack coat, a soldier's overcoat, one pair of blankets in summer and two in winter, a piece of India rubber for blankets, a pair of gauntlets, a small bag with needles, thread, &c.; a sponge, hairbrush, comb, soap, &c., in an oil silk bag; two pair of thick drawers, and three or four towels. Such money as he takes should be in silver or small gold. A person thus fitted out has no extra baggage, (which, indeed, cannot be taken,) and can travel comfortably at any season of the year.

This list of items to bring on the stage ran in the *San Diego Herald* in November 1857 and was reprinted in other papers. Included in the items were a Sharps rifle, cartridges, revolver, knife, thick boots, woolen pants, socks, undershirts, a "wide-awake" hat (soft, low-crowned felt hat), India rubber, needles, thread, hairbrush, soap, towels, and money in silver or small gold. No extra baggage was allowed.

Experienced in running stages in Texas, George Henry Giddings (1823–1902) was appointed Birch's eastern agent for the San Antonio–San Diego Mail. His brother John James surveyed the route. Upon Birch's untimely death, Woods continued to operate the line with the help of Robert Doyle and Giddings. In 1858, Giddings purchased the controlling route interest from Birch's widow. In 1861, with his mail contracts canceled, he joined the Confederate army.

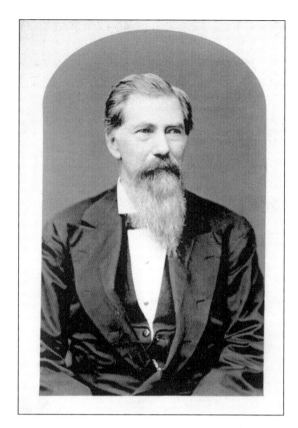

Robert Emmet Doyle (1828–1898) of San Francisco, Isaiah Woods's brother-in-law, was appointed as the western division agent from Tucson to the Pacific coast. Woods carried $20,000 from Birch to set up the line from San Antonio, but Doyle had to advance money to set up the Pacific end of the line. Later, Doyle and his wife, Sarah, made their home in Old Town San Diego's Whaley House.

On July 24, 1857, Woods dispatched the first coach, carrying mail for San Diego and intermediate military posts, from the San Antonio plaza. This coach was sent with six armed men, 36 mules (sent ahead in relays), and provisions for 30 days to last to the Pimos Villages, Arizona, and return. This 1898 photograph shows the San Antonio Post Office. (UOK.)

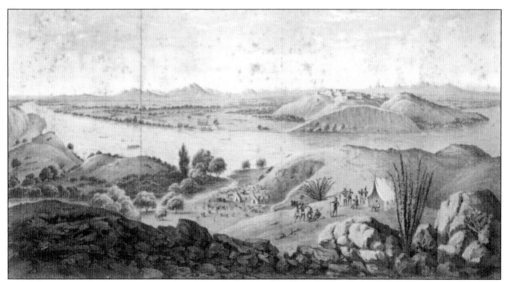

Fort Yuma was at the junction of the Gila and Colorado Rivers. In Woods's journal for September 4, 1857, he wrote: "We reached Colorado city, opposite Fort Yuma, at 11 o'clock p.m., here we changed a few of our mules, took the mail for San Diego from the quartermaster, and repaired our coach with additions of leather and rawhide. . . . Made 49 miles today."

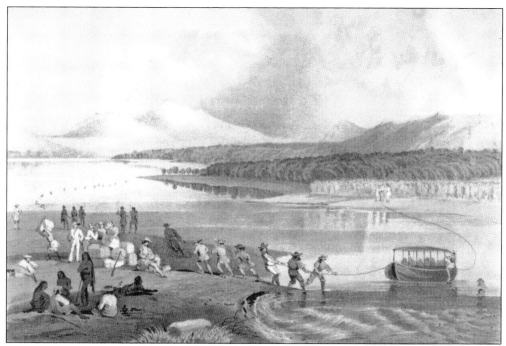

The US Pacific Railroad Expedition and Survey in 1853–1854 produced this image of the Colorado River near the Mojave villages. Crossing the Colorado River was always a major event for the thousands of trappers, traders, miners, drovers, teamsters, soldiers, adventurers, and emigrants who traveled this southern route. Starting in 1857, the stage also crossed the Colorado River.

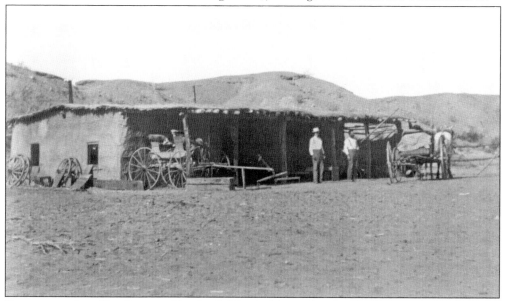

Downstream from Fort Yuma and by the California-Mexico border, a rocky formation called Pilot Knob is near the upper crossing of the Colorado River. Ferryman Louis Jaeger had his adobe home, store, blacksmith shop, and stage station there. Stagecoach, mules, and passengers were transported on his flat-bottomed cottonwood ferry. In his account for September 5, 1857, Woods wrote, "Crossed the Colorado about sunrise over an excellent ferry." (SDHC.)

The military and road builders trying to work west from Yuma faced the river's challenges and also a long chain of sand dunes, eight miles by 40 miles, which blocked travel. The strong prevailing westerly winds caused the sands to shift, making them even more of a barrier. Now known as the Algodones Dunes, these sand dunes forced the detour of the road south of the California-Mexico border. (CADPR-SDCD.)

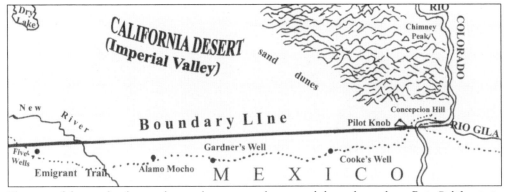

Planners of the overland stage chose a desert route that passed through northern Baja California in order to avoid the sand barrier. The stage stations through this area were primitive and sometimes without water. Stops were located at known water sources like Cooke's Wells and Alamo Mocho, which sometimes had to be cleared of dead animals. These were important stops for the military during the US-Mexican War.

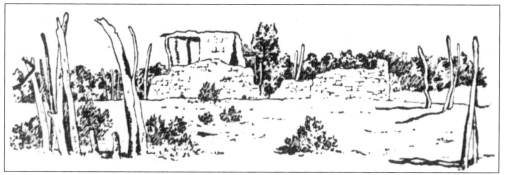

The water at Cooke's Wells was some of the best. Woods's 1857 journal had this entry: "Drove to Cook's Wells to breakfast, 20 miles. We remained encamped at Cook's Wells to rest ourselves and animals till nearly sunset, and then started to cross what is considered the worst portion of the Colorado desert, namely, a distance of twenty-two miles through heavy sand from Cook's Wells to Alamo Mucho."

This 2007 photograph of the Cooke's Wells area in Baja California shows a portion of the Alamo River. In honor of the stage's 150th anniversary, historians from Yuma and San Diego met with Mexican historians to retrace part of the route. The well, known as "first well," was renamed for the Mormon Battalion's leader, Philip St. George Cooke, who found the well dry in January 1847. (MMS.)

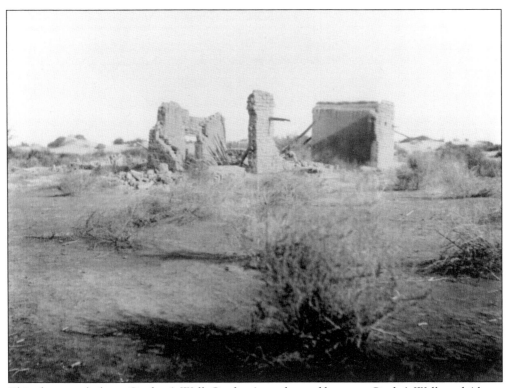

This photograph shows Gardner's Well. Gardner's was located between Cooke's Wells and Alamo Mocho in the bed of the old Alamo River. There is some dispute about whether or not this was a station for the earliest stages. Wells in this area were inconsistent. (SDHC.)

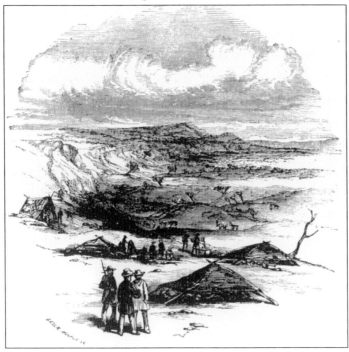

Alamo Mocho, as shown in this 1853 woodcut, was a well-known watering spot on the Southern Emigrant Trail. It was east of present-day Mexicali in Baja California. Alamo Mocho was named for cottonwoods. However, by the time the stages were running, only the stumps were left.

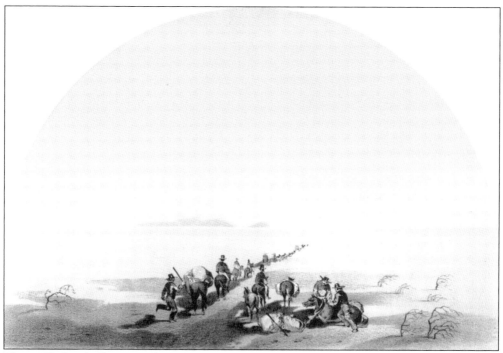

This 1853 sketch illustrates the Colorado Desert looking west toward Signal Mountain on that road. The 90-mile stretch of desert between Yuma and Carrizo Creek was challenging to all travelers. Scarce water, extreme temperatures, lack of forage, and deep sand were reflected in the scattered bones of pack animals and livestock along the trail.

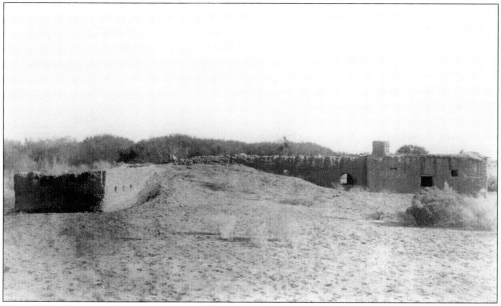

This 1882 photograph shows Indian Wells Stage Station, which was near the present town of Silsbee. The floods of 1905–1907 destroyed it. One 1857 stage traveler described the wells as small holes 20 feet underground where the "smell arising from these wells is about as delicate to the nasal organs as ever arose from a barn yard." (SDHC.)

From Indian Wells, the Birch stage route went to Carrizo Creek and Vallecito Stations (pictured in separate chapters). After Vallecito, the stage route to San Diego went on to Warner-Carrillo Ranch and then turned south. This photograph shows the steep San Diego Trail in Oriflamme Canyon that climbed to Lassator's Ranch at Green Valley. The trail required passengers and mail to be transferred to mules. (MMS.)

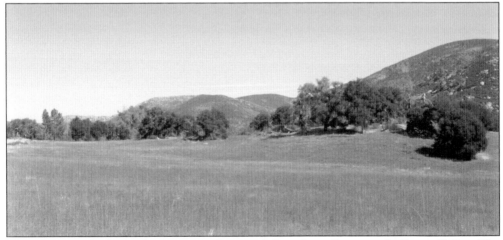

This photograph shows the area near Lassator's Ranch in Cuyamaca's Green Valley. The Lassator-Mulkins family operated Vallecito and the Green Valley home, a supply station for the desert. James Lassator and his stepsons built the stone house about 1857. One passenger wrote, "We had to sleep in a low hut with a fire in the middle" and were served "fresh butter and bread, mutton and coffee." (MMS.)

From Green Valley, passengers continued to San Diego through the foothills using coaches. The stops were the ranches of Julian Sandoval, William Williams, and Julian Ames. This view from Williams's Ranch shows the road leading east through a canyon known as Jackson's Hole. Williams married the widow Ramona Alipas de Curley, daughter of Old Town's Juana Machado, after placing an advertisement for a wife in the *Herald* in 1857. (SDHC.)

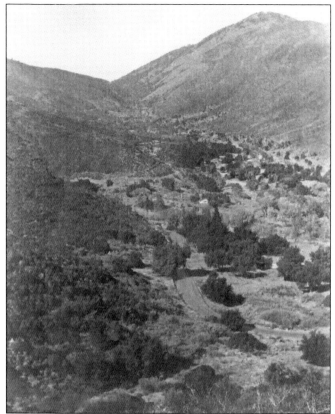

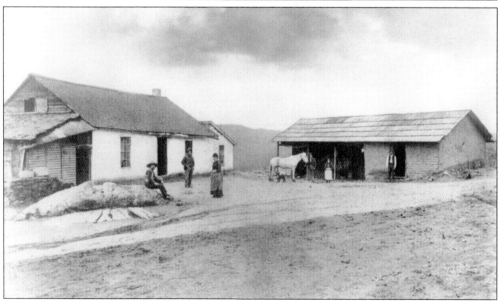

Formerly a Mission San Diego hog farm, Jesse Julian Ames's Rancho Los Coches was the smallest of the county ranchos. Charles Huning, who stopped there in January 1858, writes of being served jerked beef, tea, and tortillas by an Indian woman. The Ames family did not move there from Old Town until 1859. (SDHC.)

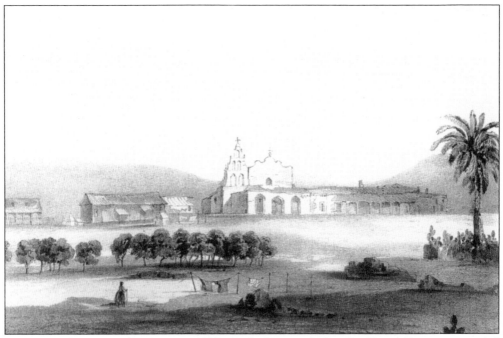

Mission San Diego, a military post in 1857, was the last stop before San Diego. Distances traveled from Lassator's at Green Valley were seven miles to Julian's (Sandoval); Julian's to Williams's, seven miles; Williams's to Ames's, 14 miles; and Ames's to Mission San Diego, 16 miles. It was another five miles to San Diego. For those riding only in coaches, the route south from Warner-Carrillo was longer.

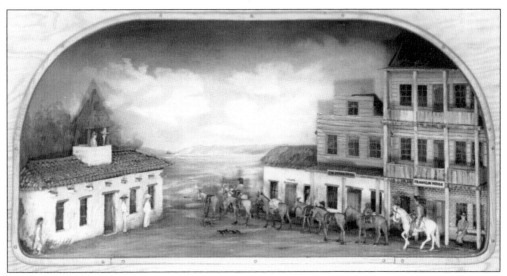

Old Town San Diego was the terminus of the San Antonio–San Diego Line. Mails were to leave on the 9th and the 24th of each month. The first mail coach to the east left San Diego on August 9. The stage men took relay mules with them and were able to obtain 10 additional mules at Warner-Carrillo Ranch for use on the desert.

James E. Mason brought the first overland mail into San Diego on August 29, 1857. He left San Antonio on July 9, 1857, with four men, including his assistant Samuel A. Ames. A second mail was sent on July 24. Due to delays, both mails came in together from Fort Yuma.

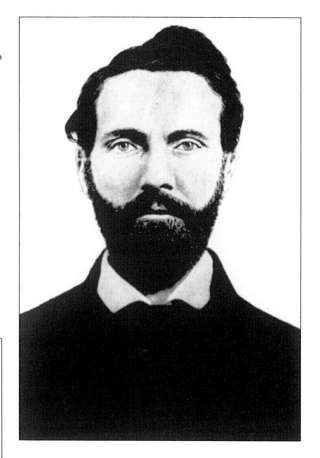

ARRIVAL OF THE OVERLAND MAIL!!!

First Trip of the San Antonio and San Diego Line!!

Unprecedented Time Across the Continent!!!

THIRTY-FOUR DAYS FROM SAN ANTONIO!!!

Superiority of the Southern Line Completely Demonstrated!!!

Latest Dates.

San Antonio de Bexar,	July 24.
El Paso,	Aug. 7.
Tucson,	Aug. 19.
Pimo Villages,	Aug. 21.
Fort Yuma,	Aug. 26.

The weekly *San Diego Herald* of September 5, 1857, announced the arrival of the Birch mail with enthusiasm. Because the cannon was unsafe, the August 29 arrival was announced by an anvil salute—the firing of two blacksmiths' anvils, each 50 times. San Diegans felt the southern route across the country had been vindicated.

While Birch's overland mail lines were completing their runs, he headed home to Massachusetts from San Francisco. In Panama, he boarded the steamer *Central America*. Caught in a fierce storm, the ship, laden with California gold, sank off Cape Hatteras. The silver baby cup he was taking to his son was rescued, but James Birch drowned. This sketch appears in *Frank Leslie's Illustrated Newspaper* from October 3, 1857.

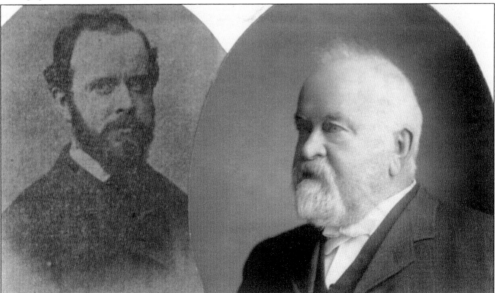

Silas St. John (1835–1919), seen in both views, rode the Carrizo to Yuma leg of the first eastbound mail. A year later, while building the station at Dragoon Springs, Arizona, he and his companions were attacked by three men with axes. St. John's arm was nearly severed and the others lay dying when the next Butterfield stage driver found them. St. John lost that arm but lived to age 84. (SDHC.)

Two

BUTTERFIELD OVERLAND MAIL LINE

The postmaster general awarded a contract to John Butterfield and others in July 1857 for overland mail service from St. Louis to San Francisco. The contract provided for two eastern terminals, St. Louis and Memphis. The route was an all-weather southern route, passing through Fort Smith (Arkansas), El Paso, Fort Yuma, and Los Angeles on its way to San Francisco. After allowing a year for preparations, service began in September 1858. The run was semiweekly, with over 2,800 miles to be covered in a maximum of 25 days.

When James Birch drowned in September 1857 with the sinking of the *Central America*, the first transcontinental line, the San Antonio–San Diego, was shaken but not defeated. It continued to operate and made schedules with regularity. With the start of operations of the Butterfield, the San Antonio–San Diego contract was amended to eliminate service between El Paso and Fort Yuma. This left the Birch line with only the San Antonio to El Paso portion and the Fort Yuma to San Diego run, with the Butterfield coaches running between the two ends.

The Birch and Butterfield lines in San Diego County covered the same desert route, with one going to San Diego and the other traveling northwards to San Francisco. Stage stops were in the same county locations, and obstacles faced were the same—desert, mountains, remoteness, and lack of water. Butterfield employees dug wells and improved portions of the road. Stations were established, supplies were procured and transported, animals and equipment were purchased, and hardy employees were found to carry out the duties.

Butterfield employees were given special instructions to show respect to the public and to passengers, to leave the Indians alone and not annoy or wrong them, and to avoid quarrels and disagreements of all kinds. Stages rolled on, night and day, with only short stops for changes of teams, coaches, or drivers.

The Butterfield, like the San Antonio–San Diego Mail, was forced to change with the coming of the Civil War. In March 1861, the line was moved north to a more central route.

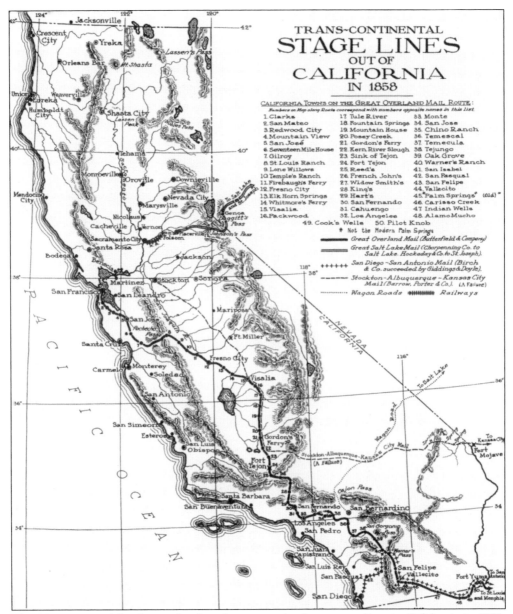

TRANS~CONTINENTAL
STAGE LINES
OUT OF
CALIFORNIA
IN 1858

CALIFORNIA TOWNS ON THE GREAT OVERLAND MAIL ROUTE:
Numbers on Map along Route correspond with numbers opposite names in this list.

1. Clarks	17. Tule River	33. Monte
2. San Mateo	18. Fountain Springs	34. San Jose
3. Redwood City	19. Mountain House	35. Chino Ranch
4. Mountain View	20. Posey Creek	36. Temescal
5. San José	21. Gordon's Ferry	37. Temecula
6. Seventeen Mile House	22. Kern River Slough	38. Tejungo
7. Gilroy	23. Sink of Tejon	39. Oak Grove
8. St. Louis Ranch	24. Fort Tejon	40. Warner's Ranch
9. Lone Willows	25. Reed's	41. San Isabel
10. Temple's Ranch	26. French John's	42. San Pasqual
11. Firebaugh's Ferry	27. Widow Smith's	43. San Felipe
12. Fresno City	28. King's	44. Vallecito
13. Elk Horn Springs	29. Hart's	45. Palm Springs* (Old) *
14. Whitmore's Ferry	30. San Fernando	46. Carisso Creek
15. Visalia	31. Cahuengo	47. Indian Wells
16. Packwood.	32. Los Angeles	48. Alamo Mucho
	49. Cook's Wells	50. Pilot Knob

✝ Not the Modern Palm Springs

━━━━━ Great Overland Mail (Butterfield & Company)

━━━━━ Great Salt Lake Mail (Chorpenning Co. to
Salt Lake. Hockaday & Co. to St. Joseph).

++++++ San Diego~San Antonio Mail (Birch
& Co. succeeded by Giddings & Doyle).

‑ ‑ ‑ ‑ Stockton-Albuquerque - Kansas City
Mail (Barrow, Porter & Co.). (A Failure)

··········· Wagon Roads ▪▪▪▪▪▪ Railways

This map, prepared for the overland mail centennials, shows stage lines in California in 1858, including the major towns and stage stops. The San Antonio–San Diego Mail (1857–1861) and the Butterfield Overland Mail (1858–1861) are shown as well as major wagon roads.

John Warren Butterfield, shown here about 1860, was an accomplished stagecoach manager when he took the executive reins of the Overland Mail Company as its president. Much like James Birch, he became a stagecoach driver as a young man and later controlled several lines in New York. When the Overland was organized, he was vice president of the American Express Company, which he helped to found.

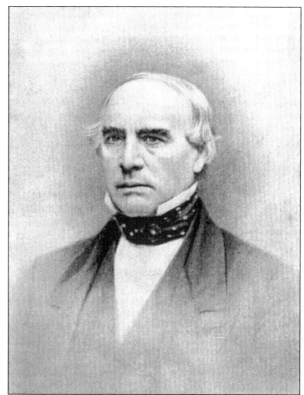

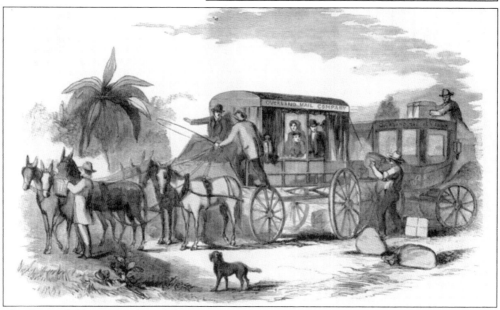

This Butterfield Overland Mail drawing appeared in the October 1858 *Frank Leslie's Illustrated Magazine*. Butterfield and his associates signed a six-year contract on September 16, 1857, to provide semiweekly mail service between St. Louis and San Francisco, which had to begin within one year of signing. The first westbound mail left St. Louis on September 16, 1858, and the eastbound had departed San Francisco a day earlier.

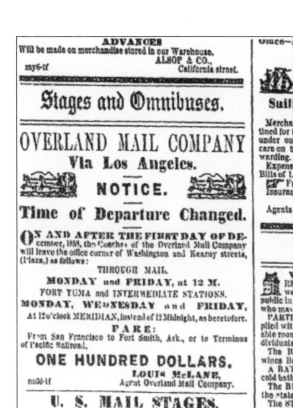

The *San Francisco Daily Evening Bulletin* ran this advertisement for the Butterfield line in December 1858. Initial fares were stated to be $200. As shown here, the rate advertised was $100 west to east. By January, the price had increased to $200 again. Then, in May, it was reduced to $150. Local fares between Fort Smith and Fort Yuma were to be no less than 10¢ per mile.

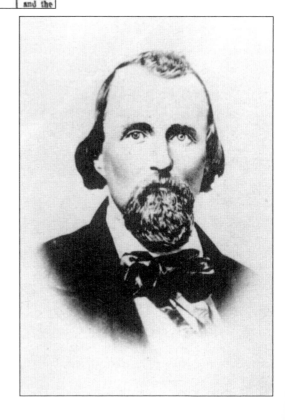

The Wells Fargo and American Express Companies held the controlling interest in the Overland Mail. Louis McLane, Wells Fargo's general agent, was asked to represent the firm in California. His name is listed at the end of the advertisement above as "Agent, Overland Mail Company." In 1866, he became president of Wells, Fargo & Company.

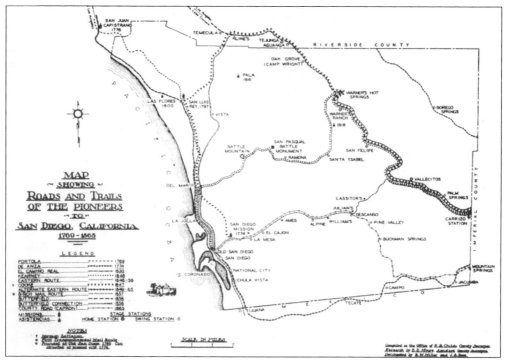

This map of San Diego County in its present size shows the Butterfield and Birch lines running alongside each other. Westbound, the Birch line went on to San Diego from either Warner-Carrillo station or took the San Diego road from the Vallecito area. The Butterfield continued up through the county and on to Los Angeles and San Francisco, not going to San Diego.

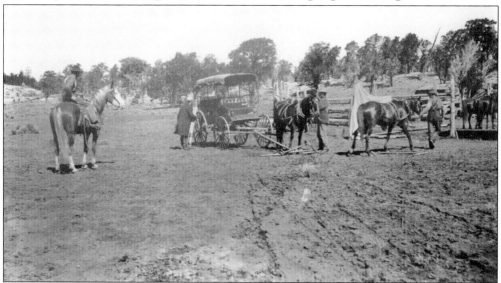

Butterfield's instructions to employees included: "Have teams harnessed in ample time, and ready to proceed without delay. Where the coaches are changed, have the teams hitched to them in time. Teams should be hitched together and led to or from the stable to the coach, so that no delay can occur by their running away. All employees will assist the Driver in watering and changing teams." (Braun.)

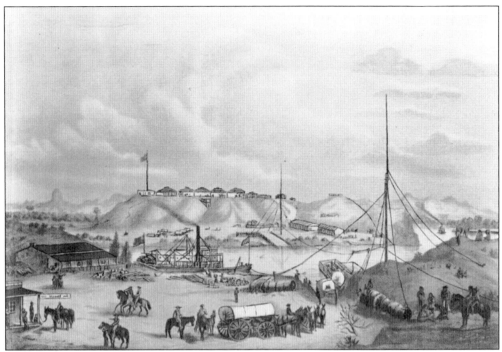

The Butterfield line entered San Diego County from the east at Fort Yuma along the Colorado River. In this lithograph, the fort is on the hill, steamboats ply the river, and there is a rope ferry that was used to transport people, wagons, and livestock across the river. Drivers sounded a horn before each station to announce their approach so a fresh team could be harnessed quickly.

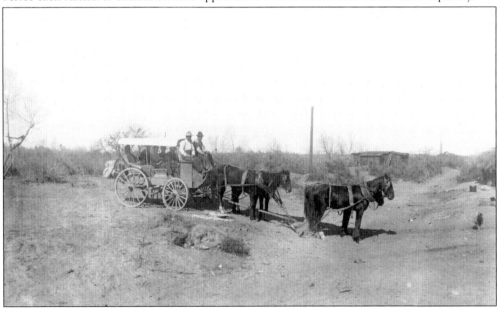

This photograph of a stage near Yuma shows a type of mud wagon. Like the Birch line, the Overland Mail used lightweight mud wagons with canvas sides, most often drawn by six mules, to cross the desert. Each passenger was allowed baggage not exceeding 40 pounds. Conductors were responsible for keeping watch over the mail and for protecting it from damage. (CHS collection, USC.)

The 1860 census included information about stage stations, listing their keepers plus the number of employees, horses, coaches, and quantity of hay and barley on hand. Note that San Felipe Station had 19 horses and two coaches with four employees. William Buckley, overland superintendent at Yuma, hired a Mr. Rapalye of San Diego to provide hay to his stations at the rates of $40 to $130 per ton. (SDHC.)

SCHEDULE 5.—Products of Industry in *Agua Caliente Township* in the County of of *California* during the Year ending June 1, 1860, as enumerated by me, *Geo.* Post Office *Temecula*.

Name of Corporation, Company, or Individual, producing articles to the annual value of $500.	Name of Business, Manufacture, or Product.	Capital Invested, in real and personal estate, in the Business.	RAW MATERIAL USED, INCLUDING FUEL.			Kind of Motive Power, Machinery, Structure, or Resource.	AVERAGE NUMBER OF HANDS EMPLOYED.		WAGES.	
			Quantities.	Kinds.	Value.		Male.	Female.	Average monthly cost of male labor.	Average monthly cost of female labor.
1	2	3	4	5	6	7	8	9	10	11
Indian Wells Station / John Pettus, Keeper	Overland Mail Co.	$1,200	24,000 lbs / 12 tons	Barley / Hay	1,400 / 840	5 horses / 1 coach	2		$130	
Pockets Station / Leo Taylor, Keeper	"	1,200	24,000 lbs / 12 tons	Barley / Hay	1,200 / 720	5 horses	1		40	
Carrizo Station / Wm Bates, Keeper	"	1,200	24,000 lbs / 12 tons	Barley / Hay	1,040 / 720	5 horses	1		40	
Palm Springs Station / J. White, Keeper	"	1,200	24,000 lbs / 12 tons	Barley / Hay	1,040 / 600	5 horses	1		40	
Vallecita Station / W. Johnson, Keeper	"	1,500	24,000 lbs / 12 tons	Barley / Hay	1,230 / 800	6 horses	1		40	
San Felipe Station / W. F. Hall, Agent	"	5,000	96,000 lbs / 36 tons	Barley / Hay	2,740 / 1,440	19 horses / 2 coaches	4		100	
Warners Ranch Station / Alex. Vance, Keeper	"	1,000	24,000 lbs / 12 tons	Barley / Hay	720 / 300	4 horses	1		40	

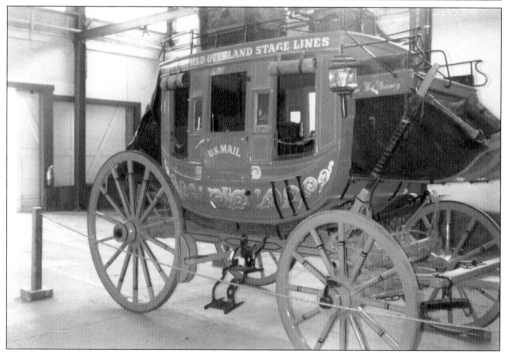

This Concord coach is a lasting reminder of the Butterfield Overland Mail. It is displayed in Arizona's Yuma Quartermaster Depot State Historic Park. Concord coaches were made in Concord, New Hampshire, for Abbot-Downing and Company. John Butterfield purchased about 100 of these coaches to start the entire line. (MMS.)

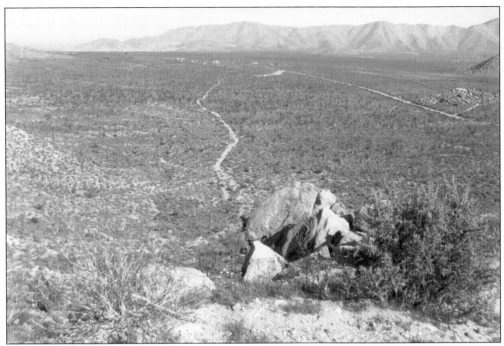

This 2010 photograph looks down on Vallecito Valley from Campbell Grade. The old wagon road is still visible. From Yuma, the Overland Mail traveled to Pilot Knob, looped below the border to Alamo Mocho, crossed back into California, and headed to Carrizo and Vallecito. One traveler in 1859 wrote of leaving Yuma at 11:00 a.m. Thursday and reaching Los Angeles on Saturday evening, having traveled a distance of 280 miles. (MMS.)

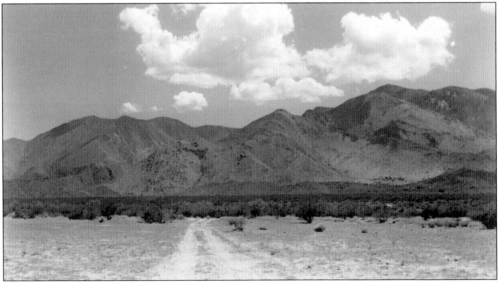

California Highway S-2 is shown here unpaved in the Mason Valley area beyond Campbell Grade. In 1858, journalist Waterman L. Ormsby Jr., the first through passenger on the Butterfield, wrote in the November 19, 1858, *New York Herald*: "From Little Valley [Vallecito] the road leads, through a rough cañon, over a steep and stony hill into another valley, whose only characteristic is an abundance of grease weed [greasewood], which whether wet or dry is excellent fuel."

The next obstacle for the stage was Box Canyon, or Cooke's Pass. In January 1847, the Mormon Battalion, under the leadership of Philip St. George Cooke, encountered this very narrow pass. Using only crude hand tools over two days, men hacked out an opening sufficient to accommodate their wagons. Ten years later, Butterfield workers made another cut nearby.

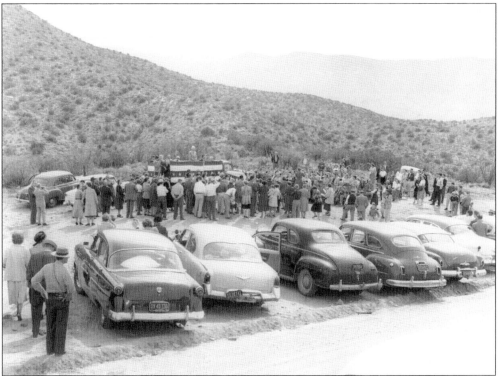

On March 28, 1954, a marker commemorating the efforts of the Mormon Battalion at Box Canyon was dedicated. A large gathering of people, including descendants of battalion members, honored their achievements, especially that of building a wagon road from Santa Fe, New Mexico, to California. Box Canyon can be found off Highway S-2 between Mason Valley and Blair Valley.

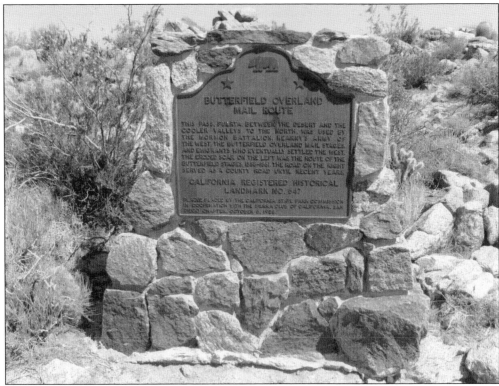

In Anza-Borrego Desert State Park, the California Historical Landmarks marker seen above honors the Butterfield Overland Mail and Foot and Walker Pass. The steepness of the grade between Blair and Little Blair Valleys was so difficult for stages that passengers had to get out and walk. Sometimes they had to push the stage over the pass. The road going up Foot and Walker Pass is still visible below. In May 1859, one journalist wrote of the passengers having to get out of the coach and walk ahead of the stage. A herd of wild cattle from Sonora was also on the road. Suddenly, one animal took off running toward one of the walkers. The timely appearance of the stage saved him. (Both, MMS.)

This aerial photograph shows the county road at Blair Valley and Little Blair Valley in Anza-Borrego Desert State Park. Both valleys have dry playas (lake beds). The tracks of the Butterfield Stage can be seen in the photograph. Journalist Waterman Ormsby wrote about this section of good road across the dry lake bed, which they encountered after the deep passes they had just navigated. (CADPR-CDD-BARC.)

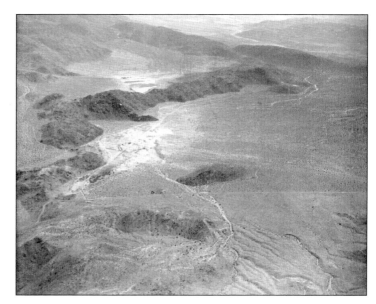

This 1958 photograph shows Blair Valley, looking into Earthquake Valley (or Shelter Valley) and down the Butterfield trail from the southeast. One 1859 traveler wrote: "On we came, night and day, with never an intermission of time except for changing horses; and twice a day, or sometimes night, an opportunity would be given us to drink a cup of coffee and swallow a few hasty morsels." (CADPR-CDD-BARC.)

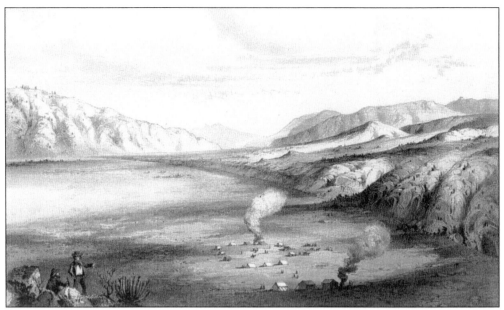

The next stage station was San Felipe, between Vallecito and Warner-Carrillo. This early railroad survey drawing shows Warner's Pass from San Felipe. While no trace of San Felipe Station has been visible since 1955, it was the headquarters for the desert division. Most old-timers who were interviewed in the 1930s remembered San Felipe station as wooden and *L*-shaped, 55 feet across the front and 45 feet deep.

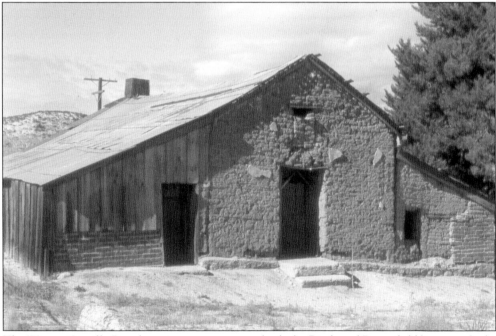

The Warner-Carrillo Ranch, an important stop on both the Birch and Butterfield lines, marked a decision point for travelers. Those people going to San Diego along the Southern Emigrant Trail would turn southwest at the fork in the road, while travelers riding the Butterfield stage would continue on north to Oak Grove, Aguanga, and Temecula. (MMS.)

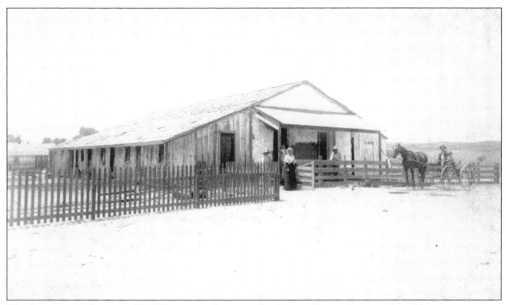

The Louis and Ramona Wolf home and store, which is still standing, is the oldest structure in Temecula Valley. Although the Wolf store was probably not the original Butterfield station, it did serve as a stage station with rooms for travelers. The Butterfield route passed along this road.

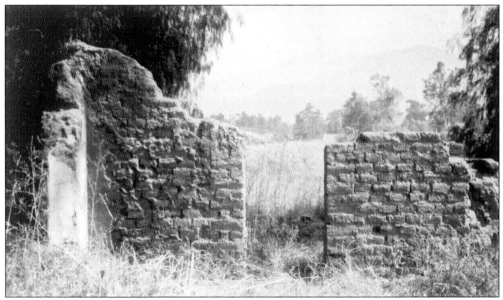

From Temecula, the Butterfield Overland Mail went on to Laguna Grande (Elsinore) and Temescal in Riverside County. This 1929 photograph shows ruins at Temescal that were thought to be the site of the Butterfield stage station. Californio rancher José Leandro Serrano's second adobe was also located here.

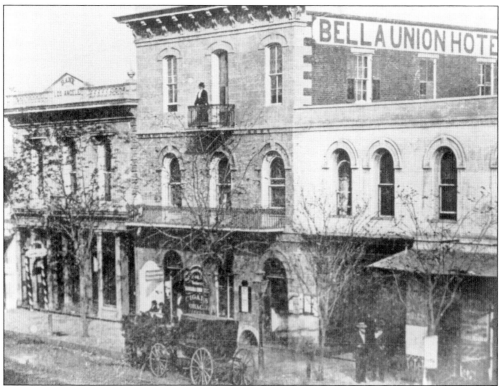

Stage driver Warren Hall brought the first westbound Butterfield Overland Mail into Los Angeles at the Bella Union Hotel on October 7, 1858. The Butterfield Company rented space in the hotel until it could build its own offices. Stage driver and contractor Phineas Banning operated his local lines to Wilmington and San Bernardino from here. (CHS collection, USC.)

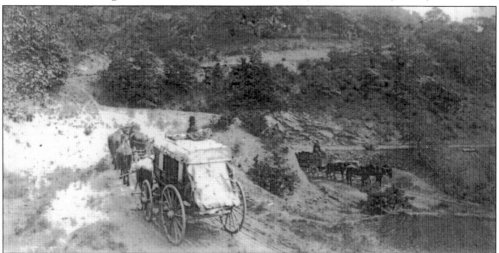

The Butterfield Overland Stage made gradual improvements in travel time. The schedule called for 25 days between St. Louis and San Francisco; that time later decreased to less than 22 days. Mail carried was letter material only, and some major newspapers were carried each way. More short-distance passengers rather than through passengers used the stage, making it an important service to isolated communities along the route.

Three

CARRIZO CREEK
STAGE STATION

The water at Carrizo Creek Stage Station was the main reason travelers stopped here. The station was located on a hill next to a small spring in a sandy wash. People traveling the 90 miles west from the Colorado River had inconsistent water resources, and many noted that Carrizo Creek was so small that a man could usually walk over it. But for those who needed water, it was greatly appreciated.

Prior to the stage companies using Carrizo, it was used by the Army of the West, the Mormon Battalion, California gold-seekers, and the men of the US Boundary Survey. They all wrote about its welcome water. Following the Southern Emigrant Trail, thousands of travelers, plus livestock, stopped here. In 1858, over 25,000 Mexican sheep, destined for California markets, rested at Carrizo. The same year, 3,000 sheep drowned in the waters. Eventually, the grass became sparse as the water fluctuated.

Carrizo Creek was also an important stop along the San Antonio–San Diego Mail route. In October 1857, Carrizo was equipped with mules and supplies. It was a place of rendezvous where people from San Diego changed stages to reach Yuma and those from Yuma boarded the San Diego stage. Nevertheless, conditions were primitive. The company used the original adobe house, although the roof had been burned. The Butterfield Company used the same building and the spring. Since these stages operated 24 hours a day, the company used the station primarily to change horses.

During the Civil War, the stages stopped running. The stage stations, however, served a vital role, operating as supply depots and watering places. After the war, Carrizo Creek functioned as a stage stop with keepers until 1875. Then the area was used seasonally to graze cattle. Today, the Carrizo Creek Stage Station site, located near the San Diego–Imperial County border, is part of Anza-Borrego Desert State Park.

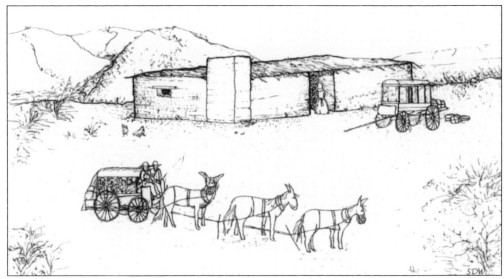

Archaeological and historic research conducted by California State Parks showed that once Carrizo Stage Station looked like this drawing. It had two small, parallel adobe buildings on a cobble foundation with thatched roofs and earthen floors. One wooden door provided entrance, and the windows were small, keeping the house cool in summer and warm in winter. An earlier structure had been made of branches and twigs. (CADPR-CDD-BARC.)

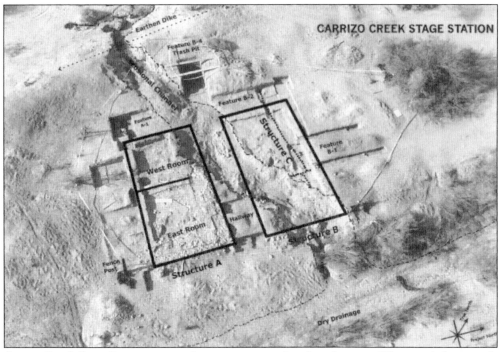

Carrizo Creek Stage Station was a welcome site to people riding the stage. This aerial photograph with overlay shows the outline of the buildings as found during archaeological excavation. Features A-1, A-2, and B-4 were trash pits. Feature B-1 was a wooden structure that burned; its function is unknown. Feature B-2 consisted of wood ash, square nails, and burned barley seeds; it was probably a feed storage area. (CADPR-CDD-BARC.)

The Army built an adobe building in 1855 at Carrizo, and a storekeeper was headquartered there. When summer temperatures reached 100 degrees Fahrenheit or higher and there was almost no shade along the desert trail, such buildings were a respite to all travelers. This 1880s picture shows that very little remained of Carrizo Station when trail use declined. (SHDC.)

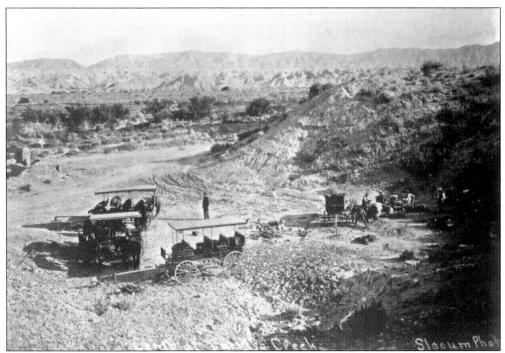

This photograph from 1904 shows the creek bed and crumbled remains of the stage station at the far left. Vandalism, fire, and an earthquake all contributed to the building's demise. Despite its remote location, Carrizo Station remained a place of historic interest to San Diegans, as evidenced by the people on a camping trip to see the old stage stations. (SDHC.)

This 1921 photograph (people unknown) shows the fireplace at Carrizo. Life there was tough and often violent. In 1857, agent William Mailland, in a drunken rage, murdered his Indian wife. An Army deserter told of being at Carrizo when a large number of Indians arrived to kill Mailland. When the soldiers appeared, the Indians left. The body was buried there, and Mailland escaped to Mexico.

During the San Antonio–San Diego Mail years, Carrizo provided meals, drink, and livestock feed. The station keeper also tended the mules and horses. During the Butterfield Line years, the keeper was responsible for the horses. Artifacts recently excavated show that animal husbandry and munitions were the largest category of items recovered, reflecting the function and dangers of the station. (CADPR-CDD-BARC.)

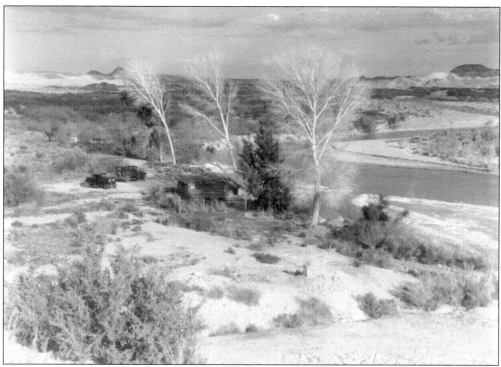

When Carrizo Creek was flowing, water could be abundant, as shown in this 1935 photograph. The first passenger on the westbound Butterfield stage in 1858 noted that plenty of water could be found at Carrizo by digging. The wooden shack in this picture may have belonged to an Augustus Asbeck, the first official owner, or to the McCain family, who had livestock operations here in the 1900s. (SDHC.)

Many travelers commented on the vegetation and sand. When leaving Carrizo in 1858, a Butterfield passenger remarked on how sandy and barren the countryside was and that it was covered with "many varieties of curious weeds." He particularly mentioned the maguey plant or mescal (agave), shown here, which was known for providing nutritious food and drink. (DEN.)

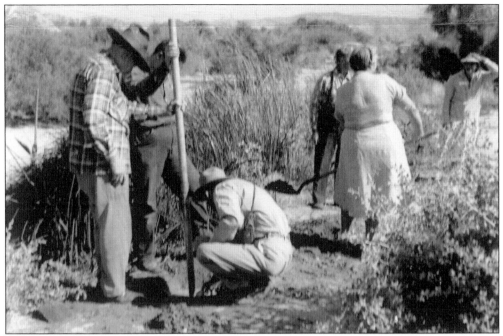

Midway between Carrizo and Vallecito is Palm Springs, named for the 20 to 30 Washingtonian Palms and multiple springs that originally were found there. Travelers cut down all the trees by the late 1800s. In 1957, the Overland Mail Centennial Committee planted some Washingtonian palms at the site of the stage stop. In addition, members erected a historical plaque. (CADPR-CDD-BARC.)

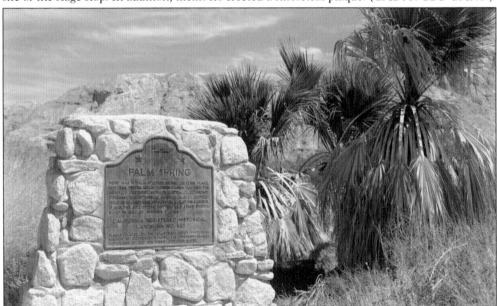

Archaeological excavations at Palm Springs (Palm Spring) produced no information regarding the location of a stage station. However, the 1860 Census showed that John White, a 30-year-old New York man, was the hostler at Palm Springs. He had 12 tons each of hay and barley and five horses stabled there. The location is now part of Anza-Borrego Desert State Park and can easily be visited. (DEN.)

Four

VALLECITO STAGE STATION

No one knows how Vallecito (Little Valley) got its name. From the earliest Spanish colonial times, Vallecito was a major stopping place on the road from San Diego to Yuma. In 1782, returning to San Diego from the Colorado River, Pedro Fages stopped at the springs of Vallecito and was probably the first Anglo visitor. He was following a well-established Indian trail. Vallecito had abundant and reliable water and reliable grass. People traveling west from the Colorado River to California stopped here after 90 miles of heavy sands, inconsistent wells and provisions, and constant fear of death. They often called Vallecito an oasis. Unknown thousands of people arrived between 1782 and the late 1880s, and thousands of cattle and sheep drank from its springs.

The first residents at Vallecito were the native Kumeyaay and Kwaaymii. Military men were stationed there during the mid-1800s. When the immigrants began to come in droves, the Lassator-Mulkins, Hart-Wilson, and Ayers-Mason families provided shelter, food, water, hay, and barley. Sarah Lassator was there for 12 years until her husband was murdered; Mary Hart lived in Vallecito until her husband died in 1867, and she married "Red" Wilson, and they lived there for another six to eight years; then Jesusa Ayers was there for seven years with her five children until her husband abandoned them, and she married James E. Mason Jr., and they lived there another eight years. Life was not easy for these women and their families, but they called Vallecito home.

Vallecito is best known as a stage station for the Birch and Butterfield stage lines. But it also served as an important military post during the Civil War. Stages resumed when the war was over. As roads and rail transport became more reliable, people no longer wanted to travel in wagon trains, and stage stops like Vallecito lost their customers. By 1888, the building was abandoned. The springs remained and continued to be an important source of water for ranchers well into the mid-1900s.

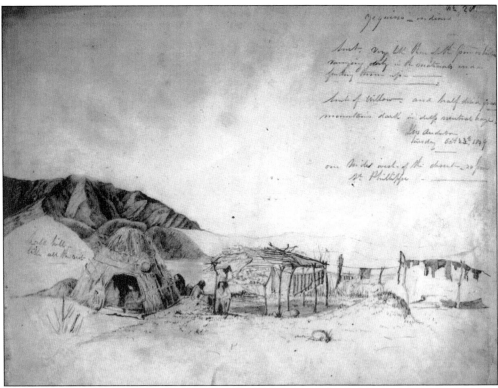

The Vallecito Indian village was called Hawi. For thousands of years, the Kumeyaay and Kwaaymii people spent winters in the desert. Consistent water drew them to the spot as it did the Spanish, Californios, and Americans of later years. This October 1849 drawing by John Woodhouse Audubon shows Hawi. The 1860 census listed 29 Indians living in five different houses at Vallecito, with some people 70 to 80 years old. (Braun.)

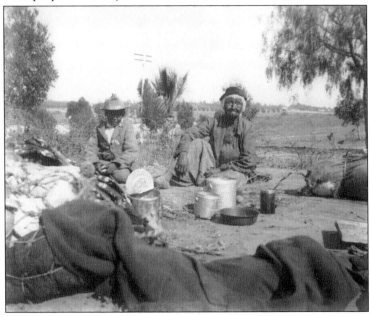

The people of Hawi lived on their ancestral land at Vallecito and in the Cuyamaca Mountains. They were often mentioned in military or emigrant diaries. Taken about 1890 by Dr. Edward Fly of National City, this photograph was believed to show some of the last of the Vallecito Indians, probably displaced to the outskirts of San Diego. (SDHC.)

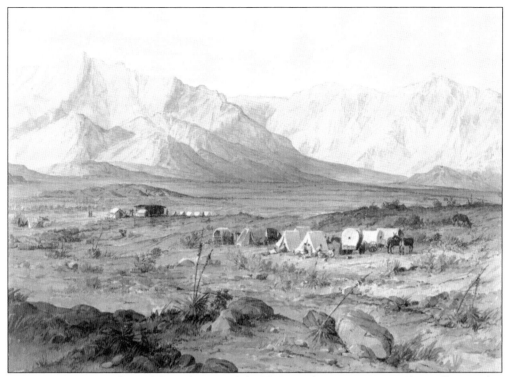

On June 2, 1852, members of the military and the US Boundary Survey stopped at Vallecito. This Seth Eastman watercolor, part of the Boundary Survey's work, is the earliest image of Vallecito. It shows the army subsistence depot, a 12-foot-by-10-foot sod storage building, which was the basis of the Lassator-Mulkins family home. Tents, mules, and wagons, plus a detachment of 24 soldiers, are pictured against the mountains. (RISD.)

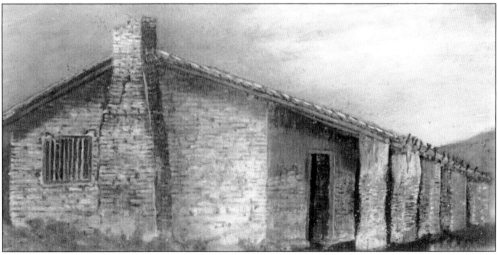

The Lassator-Mulkins family built a large sod home in the desert where children were born, couples married, and people recovered from the strenuous travel. Vallecito was an official stopping place for the San Antonio–San Diego Mail. From here, mail-carrying mules took a trail south to Lassator's Green Valley Ranch, while people in coaches traveled to San Felipe and Warner-Carrillo. Kate Brown Stephens painted this picture about 1882.

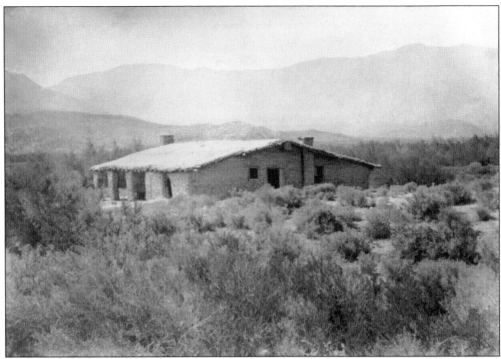

Vallecito was also one place where California immigrants and gold-seekers rested. When the first overland mail arrived in San Diego, newspaper reporters interviewed the riders. They noted seeing a wagon train of 100 wagons and considerable stock heading to Northern California and that they would be stopping at Vallecito. This 1890 photograph is the oldest one known of Vallecito. (SDHC.)

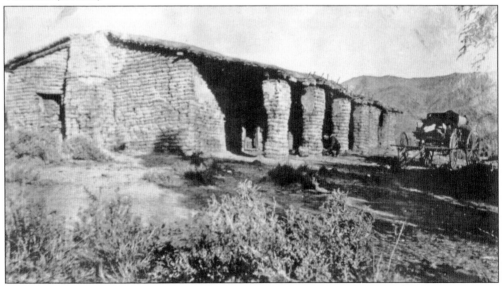

On the first Butterfield Overland Mail in 1858, journalist Waterman L. Ormsby was a passenger. At Vallecito, he noted that an emigrant train had stopped there also. The train began in Texas with 33 wagons, but at Vallecito there were only seven wagons and about one-tenth of the cattle left. This illustrates the difficulty of the passage across the desert for travelers. (Braun.)

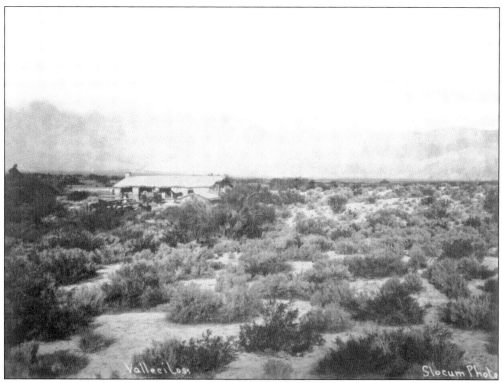

Vallecitos. Slocum Photo

During the Civil War, soldiers once more were part of Vallecito. The Army had maintained a camp there until December 1861. The military patrolled the stage roads in an effort to protect California from Southern sympathizers, who were leaving the state for Arizona and the South. After the war, emigrant traffic increased again until railroads and better roads were available in the early 1870s. (SDHC.)

The Lassator-Mulkins family called Vallecito home for 12 years. In 1866, John and Mary Hart took over the responsibility of caring for stages, travelers, and their livestock. Tragedy struck when John Hart died in 1867 at age 31. He was buried in the Vallecito cemetery, and this headstone marks his grave. Mary married John C. "Red" Wilson, a stage driver, and they remained until the early 1870s.

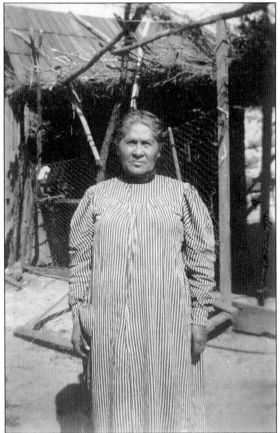

Charles Ayers, his wife, Jesusa, and their two children moved there in the early 1880s. Previously, Ayers managed the John G. Downey sheep ranch at Warner-Carrillo. Ayers disappeared, leaving his family alone. Jesusa (center) obtained a divorce and married James E. Mason Jr. (right), shown in Mason Valley with miner Ed Dolloff. Three Mason children were also born at Vallecito. (JAB.)

Jesusa Cariaga Ayers Mason, shown here in 1906, was born to a prominent Californio family about 1845. She was able to bear children, raise them, and keep house in this harsh desert environment. The Masons lived at Vallecito until 1888, when they moved to the next valley, now called Mason Valley. She is buried near her Mason Valley home. (JAB.)

James E. Mason Sr. began a pioneering family deeply involved with the stage lines. He was the first San Antonio–San Diego Line driver, bringing the mail from Texas in 1857. His son James E. Mason Jr. (1856–1929), pictured here in 1911, was the first patented owner of Vallecito. He married Jesusa, and their son James E. Mason III (known as Edward) was born at Vallecito.

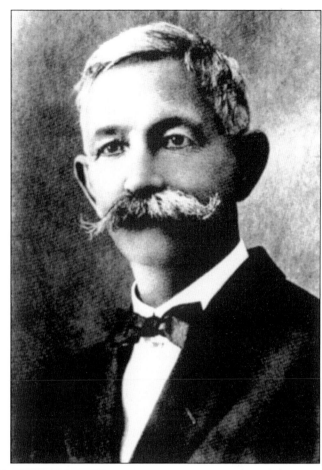

Charles F. Holland (1861–1938) bought Vallecito from the Masons in 1888. Jesusa hired attorney Holland for her divorce from Charles Ayers. Holland leased the land to cattle companies and locals like Fred Grand. In 1907, he leased 160 acres to the Campo Cattle Co. for $750 per year. Holland donated the stage station and cemetery to the County of San Diego in 1934. (CADPR-CDD-BARC.)

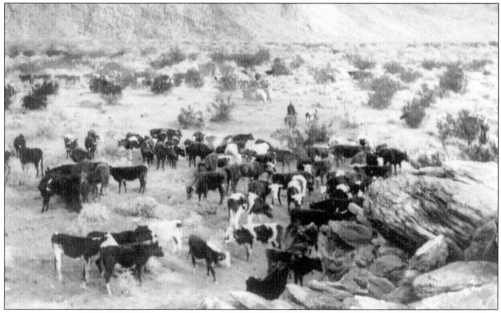

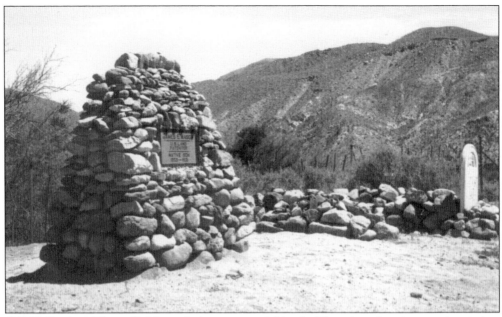

C.F. Holland and James E. Mason Jr. became good friends. They shared an interest in mining. Holland served as Mason's attorney and cared for Mason in his final years. Mason died in 1929 in Glendale. Holland kept Mason's ashes until the Vallecito restoration in 1934, requesting a monument be erected to his friend. He never lived to see the monument, which was not installed until 1949.

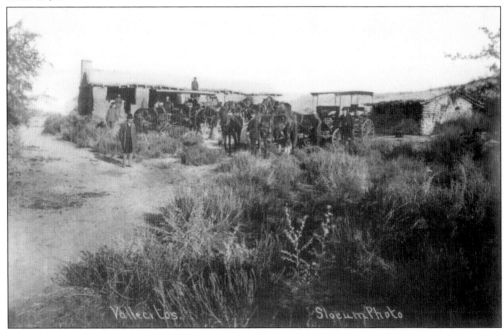

When Jesusa's son Ed Mason returned to Vallecito and Mason Valley in 1934, he was surprised at how dry the area had become. His memories were of a desert much richer in vegetation and water. Vallecito's water continued to flow, but by the early 1900s when this picture was taken, the abundance had diminished. (SDHC.)

Many people died at Vallecito. Some are buried in the cemetery and others nearby in the desert. People died from the trauma of crossing the desert, illness, old age, and murder. Many tales were told of thieves and criminals killed there. This early photograph shows how the stage station looked as it started its rapid deterioration, due in large part to tourism, vandalism, and treasure seekers. (ABC.)

This c. 1929 photograph shows the children of Edward and Mabel Marcy—Evelyn (left), Joseph (center), and Homer—posing in the Vallecito ruins. Vallecito was a destination for family picnics and camping. Evelyn's descendants still live in the backcountry and visit Vallecito, showing the continuing allure of stagecoach stations. (KF.)

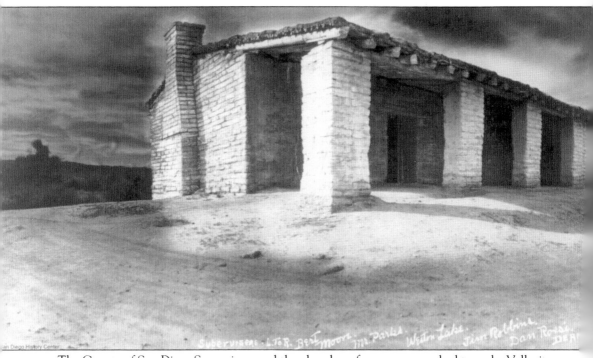

The County of San Diego Supervisors and the chamber of commerce worked to make Vallecito a tourist destination. Overseeing parks was a function of the property department. Pictured in February 1945, from left to right, are Bert Moore (surveyor's office), Rufus Parks (property department), Stuart Lake, County Supervisors Jim Robbins, Dan Rossi, and Dean Howell, John Vogt (road superintendent), and Shelby Wiggins (chamber of commerce). County supervisors

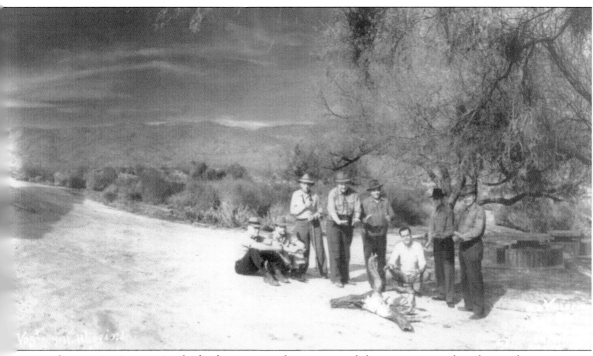

took an active interest in the backcountry and spent several days camping and exploring their county and contacting property owners in the area. They visited Borrego Valley, Mason Valley, Vallecito, Agua Caliente Springs, Carrizo Creek, and Mountain Palm Springs. Moore reported the trip in the county magazine with much kidding about the "great variety of snores that were coming from inside the tent." (SDHC.)

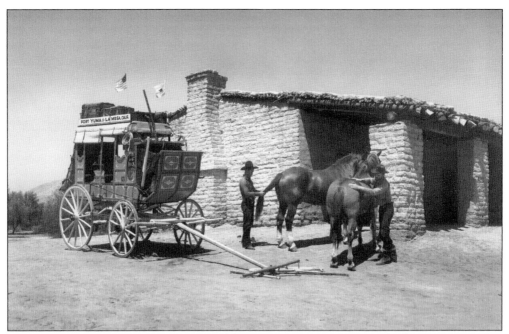

California's centennial was in 1950. In celebration, McFurson Coats and Alex Barrone took a restored Concord stagecoach and followed the Butterfield Overland Mail route from Yuma to La Mesa with the hopes of stimulating interest in the history and preservation of the stage route. This photograph shows the Fort Yuma and La Mesa stage stopping at Vallecito. (PE.)

California celebrated the Overland Mail Centennials of 1957–1958. Many people, including the Centennial Commission pictured here, participated in this event by camping or picnicking at Vallecito. The circular picnic tables were dedicated by various organizations in the 1940s and can still be seen at Vallecito. (CADPR-CDD-BARC.)

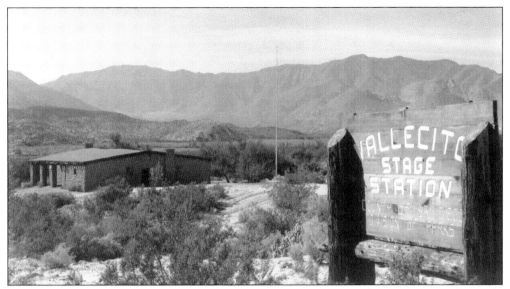

This modern photograph shows the stage station as it looks today. Behind, or south, is the newly acquired Hawi-Vallecito section of Anza-Borrego Desert State Park, where visitors can hike and ride horses. (CADPR-CDD-BARC.)

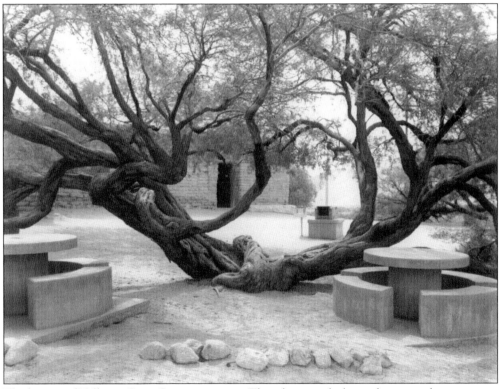

The beauty of Vallecito Stage Station remains. This photograph shows the original entrance on the road that came from the southeast and by the columns along the veranda. James R. Lassator and his Mulkins stepsons knew the benefit of a shady place for stage riders and emigrants to rest and cool down. The stage station continues to be a favorite San Diego County park.

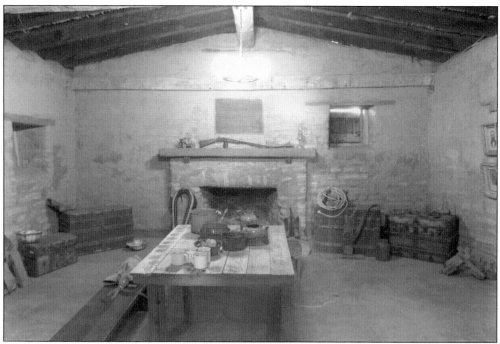

Vallecito's popularity continues to grow. In 2007, a group of volunteers and county staff began a yearly event showcasing the history of this area. In this photograph, the interior of the stage station has been restored using some of the items collected by the Strahlmann family for use in the Vallecito Museum. (DEN.)

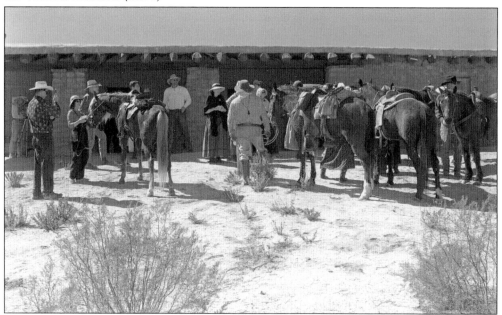

Each year for Vallecito Days, equestrians reenact the ride from Carrizo Creek and Palm Springs to Vallecito along the same trail the emigrants took. Reenactors dress in period clothing and arrive dusty and thirsty as did the original groups. The Lassator-Mulkins, Hart-Wilsons, and Ayers-Mason families would be proud to see what has become of their Vallecito home. (DEN.)

Five

Lassator-Mulkins Family of Vallecito

The people who operated the early stage stations in remote areas of San Diego County were tough, resilient, inventive, and self-sufficient. For the Lassator-Mulkins family of Vallecito, managing a stage station was a family business that included much sorrow and tragedy as well as hard work. Their story begins with Sarah Waterhouse (1817–1902).

Born in New York, Sarah married John Stewart Mulkins (1807–1852) when she was only 14. When she was 19, her parents, two brothers, her husband, and their first two children moved to Michigan to farm. Sarah and John Mulkins had three more children in Michigan, while her parents also had one more child. Then both families moved to Iowa, where Sarah lost a son but gave birth to a baby girl. Her mother also had a baby daughter.

The Gold Rush or other reasons made the Waterhouse and Mulkins families give up farming. In 1851, they joined a wagon train to California. Along the route, tragedy struck. Sarah's mother, father, and husband died. Widowed but needing to care for her five children plus a sister, Sarah persevered on to California. This experience stayed with Sarah and her children and made them better able to care for the emigrants who stopped at Vallecito.

In Los Angeles, she opened a boardinghouse and met James Ruler Lassator (1816–1865). They married in 1854, and the Lassator extended family moved to the remote military depot at Vallecito. Two children were born to this union: James Jr. and Sarah Martha. When the San Antonio–San Diego Mail Line started operations, the Lassator home on the edge of the Colorado Desert became a stage station. The family also ran a second stage stop in the mountains. The five Mulkins children were a major part of the operation.

Unfortunately, hard work did not stop heartache for Sarah. Her eldest son died as a result of a childhood injury. In 1865, James Lassator and a son-in-law were murdered a few months apart. Regrettably, Sarah moved away from her San Diego homes.

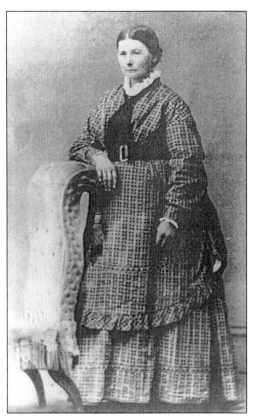

Sarah Waterhouse Mulkins survived a tragic wagon train trip to California, remarried, and settled with her children and new husband in San Diego County. She was a strong woman who cared for her family and those passengers and crew who passed though her stage stations at Vallecito and Green Valley. Her Mulkins children helped build and run the operation. Her Lassator children were born at Vallecito.

James Ruler Lassator married the widowed Sarah Mulkins, and they moved to Vallecito. Employing local Indians, he built and operated a hay road from the mountains to the desert to supply Vallecito. He served his community as justice of the peace and county supervisor (1860). On a business trip to Arizona in 1865, he was attacked, robbed, and murdered.

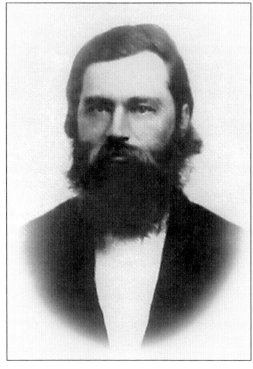

Sarah's oldest son, Andrew Mulkins (1833–1863), standing in this image, was left in front of a fire as a child and fell under a log, burning his head. The baby in the photograph is probably John Wesley Mulkins. In 1863, Andrew started having terrible headaches, and a San Diego doctor opened a hole in his head to relieve pressure. His mother nursed him at Vallecito, but he died and was buried there. (SDHC.)

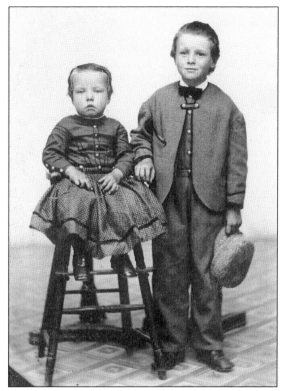

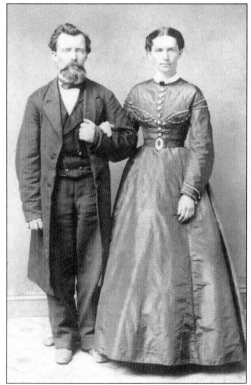

Eldest daughter Loanna Mulkins (1835–1880) was 16 when their wagon train crossed the plains. In 1852, in Utah Territory, she married John Gunnings, whom she later divorced. Returning to the family, she and her brother Andrew ran Vallecito. The 1860 Census lists her as Loanna Beard. She is photographed here with her third husband, Alfred Barlow. Loanna had one daughter who married into the Littlepage family of Ramona. (SDHC.)

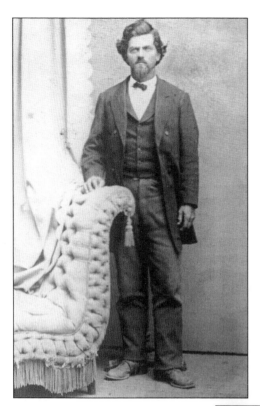

John Wesley Mulkins (1837–1907) helped his stepfather build a sod house at Vallecito and a rock house at Green Valley. Lassator and Andrew and John Wesley Mulkins formed J.R. Lassator & Co. While Andrew and Loanna managed Vallecito Stage Station, John managed, and eventually owned, the Green Valley Ranch. (SDHC.)

Jane Mulkins (1840–1819) spent her adult life in the Ramona area. As justice of the peace, James Lassator married Jane and John Dye. They are pictured with two of their five children, Arthusa (left) and Elizabeth. Prior to marriage, Captain Dye was a stage station keeper for the Butterfield Company in Arizona. After his death, Jane married David Halstead, another stage driver, and had three more children. (CSL.)

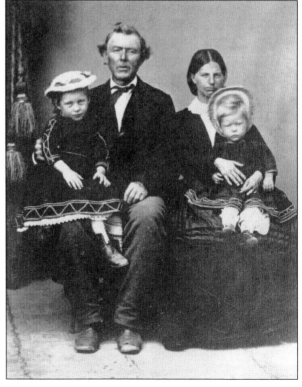

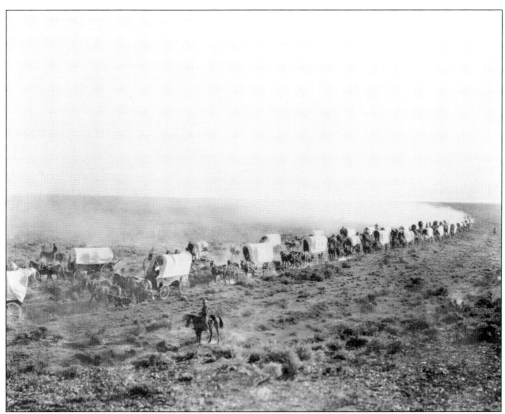

Crossing the plains in a wagon train was dangerous business—full of uncertainty and trauma. Mulkins family history relates that Indians stole their oxen and milk cow and kidnapped baby Loduska. The brave men from the wagon train got some animals back and recovered Loduska. Sarah Mulkins's parents, John and Sarah Waterhouse, and her husband, John Mulkins, died of poisoned water along the trail. (CHS collection, USC.)

Loduska Mulkins (1847–1935) was seven when the family moved to Vallecito. Pictured with Loduska are two of her sons, Edwin Kimball (standing) and Henry Williams. At Vallecito with Lassator officiating, Loduska married Cyrus Kimball, who owned a store along the stage route. Cyrus, a pregnant Loduska, and their son Edwin were traveling in 1865 when Cyrus was murdered, shortly after Mulkins stepfather's murder. (SDHC.)

James Ruler Lassator Jr. (1855–1899) was born at Vallecito. As an adult, he moved to Tombstone, Arizona, where he ran a cattle ranch. He married Sarah Emma Lee, and they had two children. For over 10 years, Lassator was embroiled in bitter quarrels between sheep- and cattlemen. His murder in 1899 eerily echoed his father's death. Despite a large reward, the murderer was never found. (SDHC.)

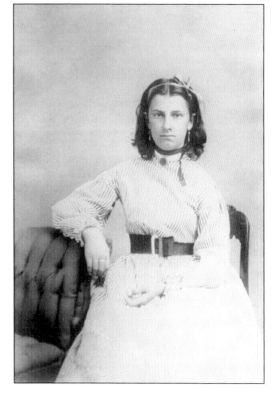

Sarah Martha Lassator (1857–1899) was born at Vallecito. Stage drivers loved the little girl and would slow down before reaching the stage station in order not to harm her. She married Silas Prior Nicholson, a gold miner, in Shasta County, and they had six children. Sarah Martha died at age 42 at almost the same time as her brother. (SDHC.)

J.R. Lassator Sr. (right) and John Wesley Mulkins (left) homesteaded 160 acres of land in Green Valley. This was an important stop along the mail routes when mules carried the mail. They also grew hay for Vallecito and Carrizo stage stations. The Lassator Hay Road was so steep that the hay wagons had the oxen on the back to act as a brake. (SDHC.)

This cattle brand belonged to Lassator and Mulkins. Rodeos, with as many as 1,000 head of cattle, were held in Green Valley. When Lassator did not return from a business trip, John Wesley Mulkins went to Arizona to find him. Instead, he found only Lassator's bones. He had to tell his mother that she had lost a second husband. After Lassator's murder, John took over Green Valley Ranch.

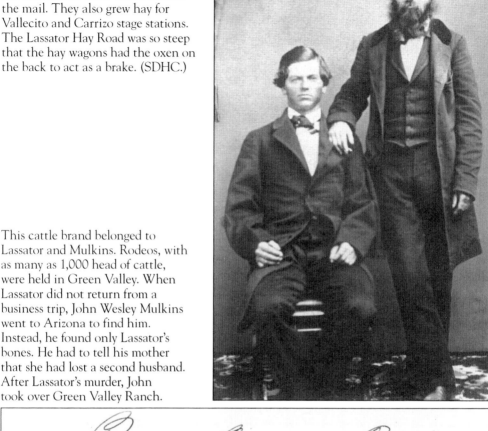

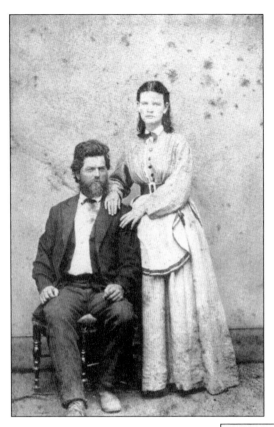

At 14, Clarissa Ann Gazaway joined Texas emigrants on a wagon train that stopped near Green Valley, where she met John Wesley Mulkins. In 1869, John and Clarissa were married. Twin girls born to them died shortly after birth. The Mulkinses adopted Clarissa's nephew in 1886 and raised him as John Gazaway Mulkins. They ran this ranch after Lassator Sr. was murdered, and Sarah moved to Nevada County. (SDHC.)

Sarah married Willard McFadden, a miner, in Grass Valley in 1867. They lived with Loduska before moving in with Jane and her husband. When Sarah's forgetfulness made it hard to care for her, she was institutionalized. After losing many of her family members to tragic deaths or murder and with only three of her eight children still alive, Sarah Waterhouse Mulkins Lassator McFadden died at age 85. (SDHC.)

Six

WARNER-CARRILLO STAGE STATION

Warner Ranch was located in a broad, flat valley and sat beside a long-established cattle trail. Jonathan Trumbull Warner was well known in early California as a state legislator, county supervisor, merchant, and ranch owner; his name stayed with the land and the buildings to the present day. Warner first saw this valley in the 1830s. He recognized the luxurious grazing lands and reliable springs and creek. Included in his ranch were the hot springs at the Cupeño village of Cupa, later known as Warner Hot Springs. Warner was granted the rancho of thousands of acres in the 1840s.

During the initial influx of gold-hungry Forty-Niners, Warner operated a store for those people who survived the arduous desert crossing. He provided flour, liquor, arms and ammunition, and other supplies. Warner also provided cattle for sale to emigrants. By 1851, he left, and other owners took over.

In 1857 to 1858, Vicenta Sepúlveda de Yorba y Carrillo and her family bought what is now known as the Warner-Carrillo Ranch, built a new house (Carrillo Ranch House), and during most of the stage years provided food, water, and grazing land to weary travelers. The Sepúlveda and Yorba families were powerful and wealthy. Throughout her life, Vicenta, one of the hard-working, intelligent Californio women, had children, siblings, nieces, nephews, and other family members surrounding and assisting her. She gave birth to 14 children over 27 years, buried two husbands (one of whom was murdered), and managed two ranches with thousands of head of cattle, several vineyards, and many vaqueros and servants. In addition to this, she also cared for emigrants and stage passengers.

The San Antonio–San Diego Mail and Butterfield Overland Mail stages stopped at Warner-Carrillo to refresh their passengers, horses, and mules. The only Civil War Union encampment in San Diego County, Camp Wright, was located on Warner-Carrillo Ranch before moving to Oak Grove. Today, the land in San Diego County's backcountry still reminds the traveler of the early days of emigrants and stagecoaches.

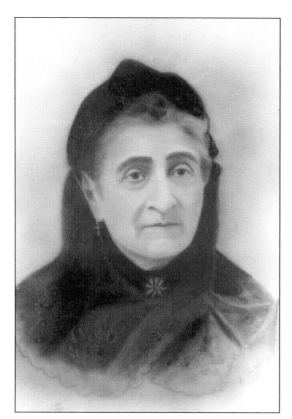

Vicenta Sepúlveda (1813–1907) married Tomás Yorba (1787–1845) in 1832, and they lived on his rancho near Los Angeles. When he died, she became a wealthy widow with 2,100 head of livestock, two vineyards, an eight-room house, and many household items. She married José Ramón Carrillo in 1847. In 1858, they bought Rancho Valle de San José (Warner Ranch) for its rich grazing lands. (Anaheim.)

José Ramón Carrillo (1821–1864) was a dashing, daring man. He fought in the Bear Flag Revolt, at the Battle of San Pasqual, and served as a Union scout and spy. He was sent on missions into Arizona and Sonora to report on movements of the Southern forces. The Warner-Carrillo Ranch provided supplies to California infantry during the war. When José Ramón was murdered, Vicenta was left with eight children. (Anaheim.)

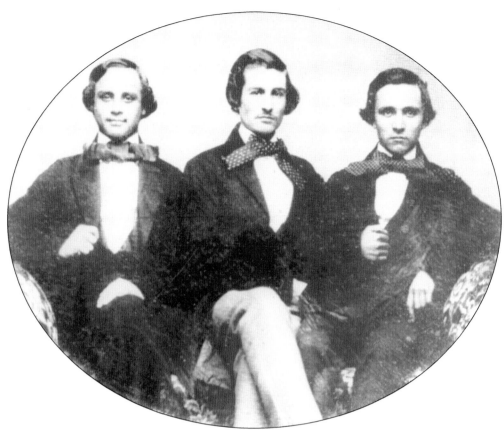

One of Vicenta's sons and two nephews are pictured here: Ygnacio Sepúlveda (left), José Antonio Yorba (center), and Andronico Sepúlveda. José Antonio was educated at Boston College and handled the business affairs for his mother at Carrillo Ranch. He was sued around 1859 to 1860 for selling liquor without a permit. He apparently thought he could continue the Warner tradition of providing alcohol to emigrants and stage passengers. (CHS collection, USC.)

Natalia Carrillo Rimpau (1859–1945) married her cousin Adolph Rimpau (1857–1916). He and his father came to Warner-Carrillo Ranch to help Vicenta following José Ramón's death. Natalia was five and Adolph seven. Over the years, many visits were made, and eventually the cousins fell in love and married. Vicenta spent her final years living with Natalia and her children. (Anaheim.)

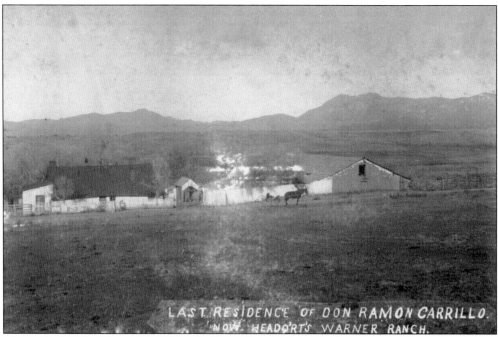

LAST RESIDENCE OF DON RAMON CARRILLO.
NOW HEADQ'RTS WARNER RANCH.

This early family photograph shows the busy Carrillo home and compound. In 1860, Vicenta and Ramón lived there with eight children, her adult son, José Antonio Yorba, her brother, José del Carmen Sepúlveda, along with his wife and four children, an elderly friend, Silvestre de la Portilla, and vaqueros and servants. All these people helped run the ranch and stage stop along the San Diego Road. (MCW.)

This tax assessment shows Vicenta's wealth when she acquired Warner-Carrillo Ranch in 1857. Additionally, the 1860 Census showed that she and Ramón had 160 bushels of wheat, 1,200 bushels of barley, and 10 tons of hay. Stages stopped here because Warner-Carrillo Ranch was located at the fork in the road where one branch went to San Diego and the other to Los Angeles. (SDHC.)

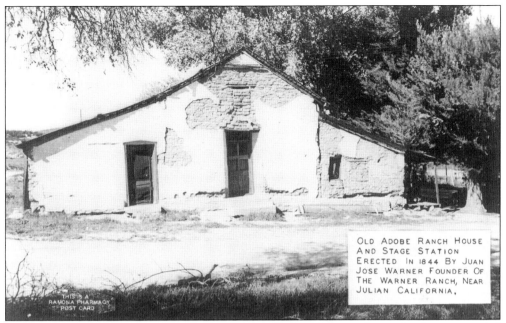

OLD ADOBE RANCH HOUSE AND STAGE STATION ERECTED IN 1844 BY JUAN JOSE WARNER FOUNDER OF THE WARNER RANCH, NEAR JULIAN CALIFORNIA.

THIS IS A RAMONA PHARMACY POST CARD

This postcard with its caption about John Warner is typical of the confusion that has surrounded this ranch. Recent research and archaeology confirm that Warner did not build or live in this adobe. The Carrillo family, despite its prominence, has rarely been mentioned in connection with the ranch or stage station. (ABC.)

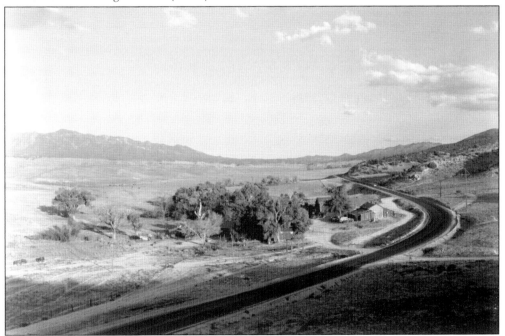

This 1936 photograph shows the lush green valley surrounding Warner-Carrillo Ranch. Many of the old oaks have been cut down, but fertile grasses remain. This valley was a haven for the weary emigrants and stage travelers who survived the trail to California. It continued as a stage stop until the late 1800s. (LC.)

This modern photograph shows the living area inside the Carrillo house. The white plastered walls and the ceiling covering, or *manta*, helped provide reflected light from oil lamps when windows were small or nonexistent. The manta was commonly used in California adobes. It was plastered and in the better homes had painted designs. It also served to prevent bugs from dropping on family and guests. (LC.)

When Vicenta and her family lived on the ranch, she employed many of the local Indians. They served as vaqueros to manage the large herds of cattle as well as working as household servants. In the early 1860s, a severe smallpox epidemic swept San Diego County. Vicenta set up cots in this barn and cared for the afflicted Indians. (LC.)

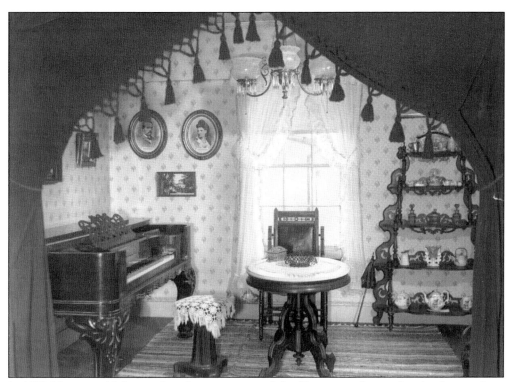

In 1870, Vicenta sold the ranch to former governor John Downey and moved to Anaheim, where she bought a house later known as the Mother Colony House. Vicenta lived in three rooms with her nine children, a granddaughter, and a nephew. Three of her daughters were married in the house. The chandelier in this photograph, hung by the Carrillo family, was presumably from the old Warner-Carrillo house. (Anaheim.)

Warner-Carrillo Ranch continued to be a cattle ranch after the stage traffic stopped. This 1905 photograph shows Samuel B. Taylor and one of his children. In 1894, Taylor and his new wife, Mary Helm Taylor, moved into the Carrillo Ranch House. Taylor was the foreman for the large Vail Ranch cattle operation. Eight Taylor children were born in that ranch house. (ABC.)

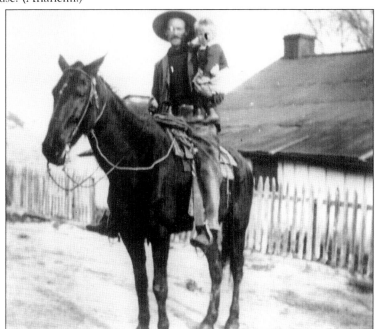

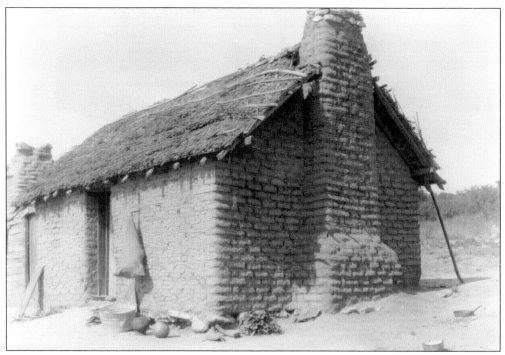

The Cupeño Indians made up the greatest portion of the workers at Warner-Carrillo Ranch. The Cupeño village, named Cupa, had healing hot springs. Before the Cupeño eviction in 1903, Cupa had 40 adobe homes (such as the one pictured here), a chapel, and a school. Several hundred acres around the village were irrigated and cultivated. In the mid-1870s, tourist stages ran from San Diego to the hot springs. (LC.)

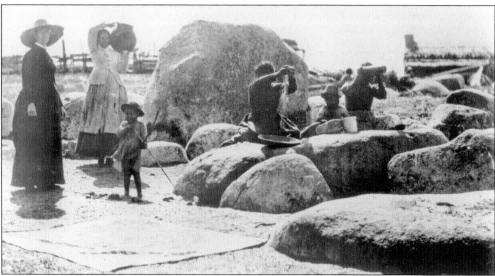

The hot springs were an economic resource for both the Cupeño and the Anglos. In the 1880s, John Downey ran sheep on Warner-Carrillo Ranch and dipped them in the springs. People in Boston bought the wool for a higher price because it was soft and luxurious. Visitors used the healing hot springs, rented houses, and bought food, baskets, and other items from the Indians. (CHS collection, USC.)

The Cupeños were skilled basket makers, known for their workmanship and artistry. The Cupeño twined basket shown has traditional designs. In addition, the Cupeño used yucca fibers, softened in the sulfur springs, to make saddle blankets. Both items were sold to tourists. (Southwest.)

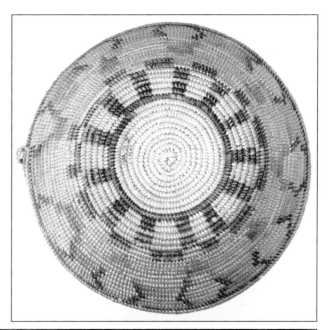

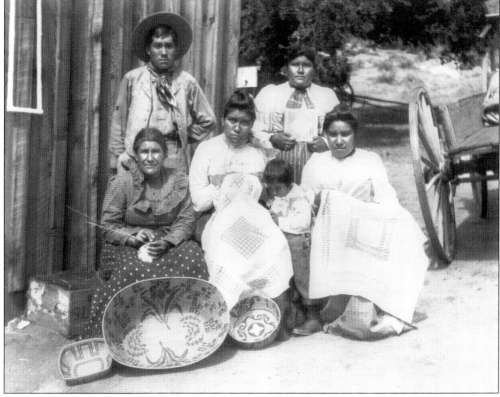

One hundred years after the US government evicted the Cupeño Indians from their ancestral home, the descendants of the Indians pictured here bought back their village in 2009. Profits from a casino allowed the tribe to purchase what was known as Warner Springs Resort. Seventeen of the original 40 adobe houses remain, as do the chapel and hot springs. (SDHC.)

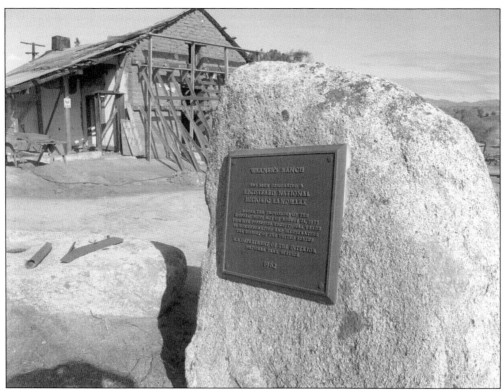

The Carrillo Ranch House is being restored by its current owner, Vista Irrigation District. This house is a National Historic Landmark. The area around the house and the barn remains a cattle ranch as it was when the Carrillo family lived here. The barn has the original hand-hewn beams and remnants of the adobe corral, which held livestock for the Carrillos and thousands of emigrants who passed by this ranch. Once restoration is complete, it will be open to the public as a house museum. (Both, MMS.)

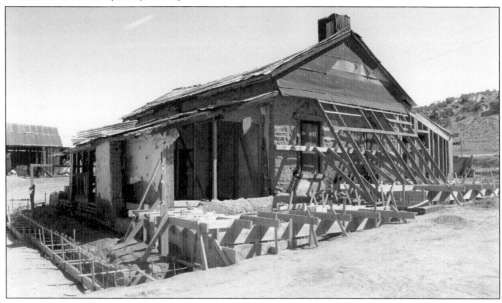

Seven

OAK GROVE
STAGE STATION

Near the Riverside County line, Oak Grove Stage Station is a reminder of San Diego County's staging history. The highway passes by the old Butterfield stage station, but few people realize its importance. Oak Grove is a small, quiet community that saw bustling activity during the late 1850s and early 1860s. Early preservationist and historian Charles F. Lummis said the pretty little valley used to be called Tévenil, meaning "a bowl-shaped basket."

Oak Grove is on an old emigrant route from the Colorado River. The Mormon Battalion passed through there in 1847, and the Butterfield Overland Stage adopted the same route in 1858. Regional superintendent of the line, Warren F. Hall, organized work on the road and the stage station. He lived there and at the San Felipe station. Another local resident, Jacob Bergman, who later was a San Diego County supervisor, may have helped lay out part of the line and drive the stages. From 1864, his home was the stage station at nearby Aguanga on the road to Temecula.

The first stage passed Oak Grove in October 1858. Stages continued to go through on their regular schedules between the Mississippi River and the Pacific, making stops at the relay station. The Butterfield line was short-lived due to sectional unrest in the nation. By March 1861, the federal government ordered the stage line moved further north across Utah and Nevada.

Union California feared the large number of Southerners in Southern California, and some men left for the Arizona Territory along the stage roads. Despite being carefully watched, retired Department of the Pacific commander Gen. Albert Sidney Johnston slipped away along that route with a small group in June 1861. By October, several companies of the 1st Infantry of California Volunteers marched under Maj. Edwin A. Rigg from Los Angeles to establish Camp Wright, first at Warner-Carrillo and then at Oak Grove. Camp Wright's purpose was to serve as a troop staging area and to prevent secessionists from reaching the South during the Civil War. The Oak Grove Stage Station served as the camp hospital.

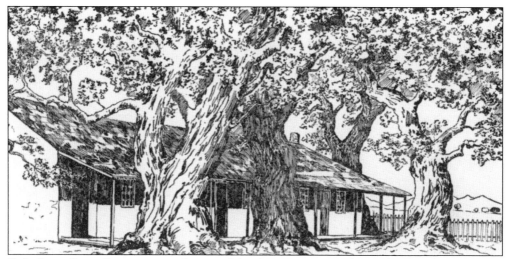

Oak Grove Stage Station was aptly named for the massive coast live oaks that abound in the area. Built in 1858 for the Butterfield Overland Mail Route, Oak Grove Stage Station is one of the very few original stage stations still in existence.

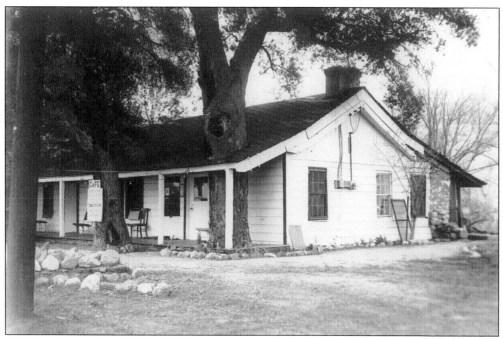

Oak Grove was built of adobe with wooden roof-support beams, probably cut with Indian labor. It was a relay or swing station, where horses and mail were exchanged, but meals were not served. In later years, it functioned as a tavern. The north and west walls were covered with board and batten siding after the strong Christmas 1899 earthquake centered on the San Jacinto Fault. (ABC.)

After being a stage stop and post office, Oak Grove became the home of James Scott Bell, who homesteaded in 1887–1888. Bell's wife, Minerva, is pictured at Oak Grove churning butter. The Bells lived in the mining areas of Banner and Julian before moving. Two of their daughters married into the Bailey and Wentworth families, who homesteaded in the area. The stage station remained in family hands until 1955. (SDHC.)

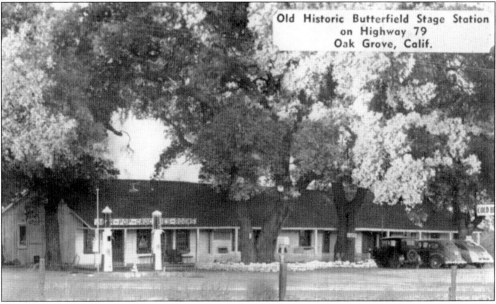

This postcard of Oak Grove shows it with gas pumps and a sign advertising "Beer-Pop-Groceries-Rooms." A business card for the tavern mentioned swimming in the cool stream at 2,750 feet, horseback riding, and fresh produce on the ranch table plus provisions for campers. Much of the surrounding area is in federal ownership. (ABC.)

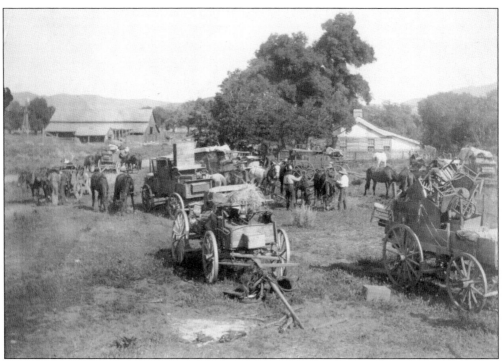

In May 1903, the California Mission Indians living near Warner Ranch were forcibly removed from their homeland. The Cupeños were evicted after a string of court cases involving former governor John Downey's ranch and resort development plans. After a disappointing last-minute appeal to Pres. Theodore Roosevelt, the Cupeños were relocated in 47 wagons driven by local teamsters. Household goods, bedding, handmade furniture, implements, clothing, stoves, ollas, baskets, dried fruits, acorns, and animals were all moved. The action was more than a physical removal of goods; it was a loss of their history, religion, and way of life. The first night on their exile journey to their new home at Pala was spent at Oak Grove, alongside the old stage stop, where the Indians refused to eat the government rations. (Both, Braun.)

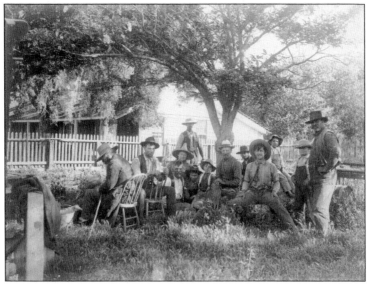

In contrast to the two photographs on page 90, these photographs show Oak Grove Stage Station as it is now—100 years later. The station remains in private hands. Oak trees cut into the building and dominate the grounds. It is located in a quiet, picturesque valley along State Route 79, and cars, not wagons or stages, pass by. In 1953, a plaque was dedicated by the San Diego County Board of Supervisors honoring Oak Grove as a state historic landmark. It is also in the National Register of Historic Places. Since the Bell-Bailey-Wentworth family owned the adobe, it has changed ownership twice. The current proprietor added antiques, life-sized figures, wagons, ox carts, and piped music. (Both, MMS.)

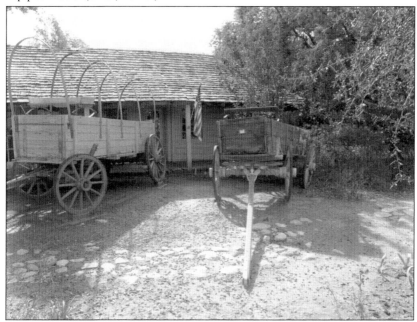

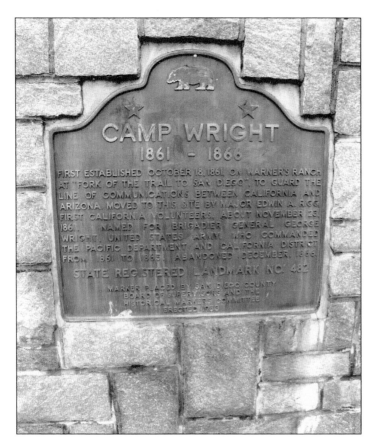

In October 1861, a Civil War camp was established near Warner-Carrillo Ranch at a fork in the road, one mile north of the Carrillo ranch house. Due to bad weather, the camp was removed in November to the Oak Grove area. Here, water, wood, and shelter were available. It was named Camp Wright in honor of Col. George Wright, commander of California troops in Southern California. (MMS.)

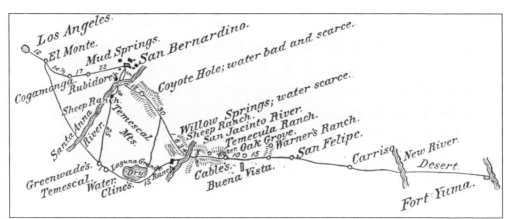

This military map shows the road from Los Angeles to Fort Yuma through Oak Grove and Warner-Carrillo. During the Civil War, stages stopped running due to secessionist activity in San Bernardino, El Monte, and other areas where Southern sympathies ran strong. Camp Wright was established to stop secessionist travel to Arizona and Texas along the back roads and to provide a staging area for the California Volunteers.

In November 1861, a party of 17 secessionists under the leadership of California assemblyman Dan Showalter traveled along the stage route in an effort to reach Texas. They were captured by Camp Wright troops at the John Minter Ranch (mistakenly labeled Minton's here) near Mesa Grande, held at Camp Wright, and then sent to Fort Yuma. They did not resist. This map shows the original Camp Wright.

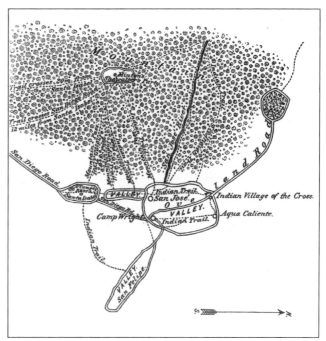

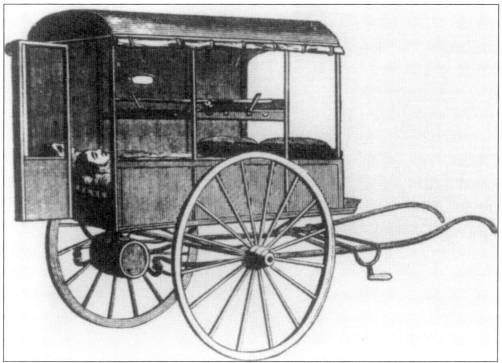

A large portion of the 2,350 troops of the California Column passed through Oak Grove. The stage station functioned as a hospital. This Coolidge cart ambulance wagon was used by California Volunteers along the road to Fort Yuma. Only small groups could be supported by the few water sources across the desert, so troops traveled at least a day apart. The camp apparently was discontinued by June 1862.

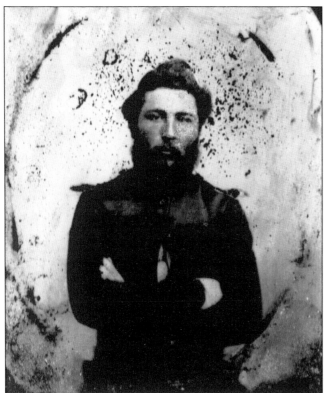

Along with the one driven by Warren Hall, the first stage to go through Oak Grove from Yuma is credited to Jacob "Dutch" Bergman. Whether or not he was on that first stage, Bergman was associated with stages. During the Civil War, he enlisted in the Union cavalry as a farrier. In 1864, he moved his family into an old stage station in the Aguanga area northwest of Oak Grove.

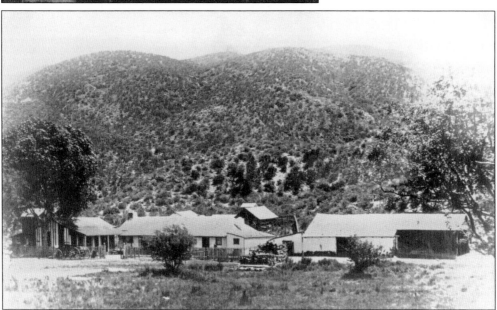

The Bergman home at Aguanga was the site of a Butterfield stage station. The area, also known as Awander or Tejungo, was between Oak Grove and Temecula. In October 1858, John M. Farwell recorded his Butterfield trip from Los Angeles and wrote of the rough road traveled. That stage reached Awander at midnight and did not arrive at Oak Grove until 4:00 a.m., traveling only nine miles. (SDHC.)

Eight

Coast and Other Local Stage Routes

With the advent of the Civil War and fear of Southern sympathizers, overland stages were moved to a more central route in 1861. Stage travel in San Diego County was very limited. The Los Angeles Stage Company ran coaches to San Diego, and mails were carried by military courier or special messenger.

Stage travel to Fort Yuma resumed first. In 1869, several contractors started operating. Albert L. Seeley had stages to Fort Yuma and ran a coastal stage between San Diego and Los Angeles, with intermediary stops at San Juan Capistrano and Anaheim. John G. Capron secured a contract for the route between Tucson and Los Angeles via San Diego and sublet the Los Angeles-to-San Diego portion to Seeley.

Shortly after these stages started running, other lines opened up. With the discovery of gold in Julian, the need for stage travel became apparent. Several contractors ran competing stages to the Julian and Banner mines. Frank Frary and Joseph Foster operated the Julian City Stage Line and also had a line that ran to the Stonewall Mine in Cuyamaca. Capron added a line from San Diego to San Bernardino. Various stages ran between National City and San Diego.

With close ties to Baja California and the interest in mining, there was a need for stages to Ensenada, Tia Juana, San Rafael, and Santo Tomás. Travel by stage continued with various operators into the 1880s, especially with the land boom when promoters took perspective buyers south of the border.

Other local lines developed somewhat later. The Campo stage, with a stop at Spring Valley, ran to San Diego in 1885. Stages from Escondido to San Diego started about 1887. Coronado had a tourist stage to San Diego in 1894 with stops at Tia Juana Hot Springs and the border monument. Various coaches also took tourists to Warner Hot Springs.

With the coming of the railroad, stage travel again dwindled. Stagecoaches operated mainly to inaccessible or backcountry locations.

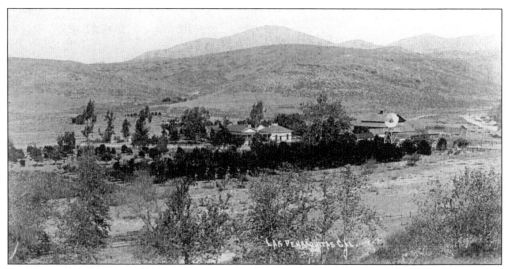

The first official public highway was named by the San Diego County Board of Supervisors on June 19, 1854. The route went from San Diego to Soledad and continued on to Peñasquitos, San Pasqual, Santa Ysabel, Warner Ranch, San Felipe, Vallecito, and Fort Yuma. The photograph shows Rancho Peñasquitos, which was part of a long canyon from coastal Soledad and running inland for several miles.

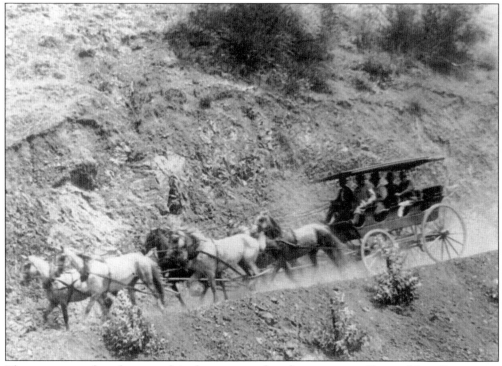

There were a number of steep roads in the county and on the stage routes. To travel from Peñasquitos to Rancho Santa María (Ramona) and on to Santa Ysabel on the public highway meant taking the San Pasqual Hill. It was a difficult climb, covered with rocks that were hard on horses and wagon wheels. Road supervisors were assigned to various routes to provide maintenance. (CHS collection, USC.)

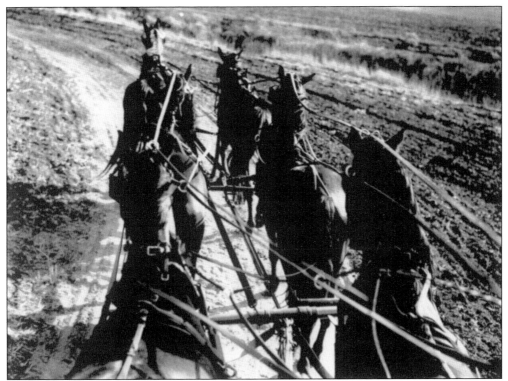

When the Butterfield line was moved to a central route in 1861, stage travel in Southern California diminished. There was some stage travel between Los Angeles and San Diego as evidenced by a diary kept by Jesús María Estudillo in 1862. He writes of a painful injury when the stage wheel ran over his foot. This photograph shows a view of the horses from the stage driver's perspective.

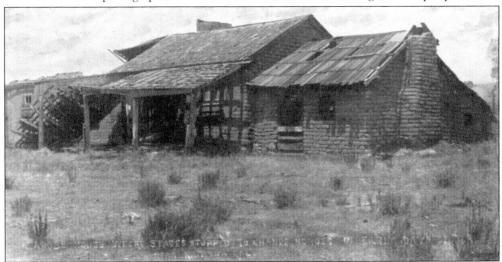

Stage travel began to increase in 1869. In that year, Samuel Warnock, George Bradley, and assessor John McIntire purchased a thoroughbrace stagecoach for making weekly trips between Ballena and San Diego. The Ballena store, post office, stage stop, and Warnock residence are shown in this photograph. In the early 1850s, Samuel Warnock and Joseph Swycaffer had a government contract to carry mail by horseback to Yuma. (ABC.)

John G. Capron (1828–1914), a Tucson merchant, came to San Diego in 1869. With a background in staging, he operated the US Mail Line with terminals at San Diego, Arizona City, and Tucson. By 1871, his four-horse stages operated triweekly with a five-day travel time. Fares from San Diego were $40 to Arizona City and $90 to Tucson, with discharged soldiers traveling at half fare.

This 1871 *San Diego Union* page shows advertisements for the Seeley and Wright stage line and John Capron's mail line. Both operations used "United States Mail" in their name, although they operated separately and in different areas. The Seeley line was more commonly known as the Coast Line Stage Company, with major stops at San Diego, San Luis Rey, San Juan Capistrano, Anaheim, and Los Angeles.

Albert L. Seeley (1822–1898), senior partner of the Seeley and Wright Coast Line, is shown with his wife, Emily. The Seeley family came to Old Town San Diego in 1867. An excellent horseman and stage driver, Seeley received a contract to carry mail and passengers between San Diego and Los Angeles. Working with another stage driver, Charles Wright, he operated the line out of the Franklin Hotel. (CADPR-SDCD.)

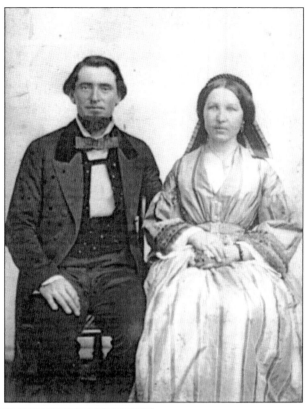

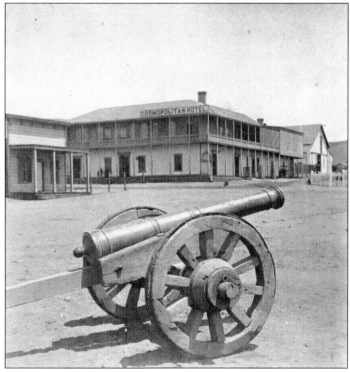

In May 1869, probably using Emily's inheritance, the Seeleys bought the old adobe home of Juan Bandini and the adjoining lots on the Old Town Plaza. They hired the Parsons Brothers to use wood framing to add a second story to the building. By the end of 1869, the Seeleys reopened the Casa de Bandini as the Cosmopolitan Hotel, complete with stables for their stage operations. (ABC.)

Francis "Frank" Albert Thompson Shaw (1846–1921) was a Coast Line driver. In 1877, while driving southbound up a steep hill near San Dieguito, his stage was waylaid and the express box taken. Shaw reported the robbery to Sheriff Edward Bushyhead, and a posse was formed. A young man of the age of 18 was arrested a few days later. (JJ.)

The Seeley Coast Line from San Diego to Los Angeles advertised stops at San Dieguito, Encinitas, San Luis Rey, and Las Flores. This photograph shows the ruins of Las Encinitas, once the home of the Andrés Ybarra family and later the stage stop for the Seeley Coast Line. The remains of the barn can be seen at the upper left. The adobe was L-shaped. (SOHO.)

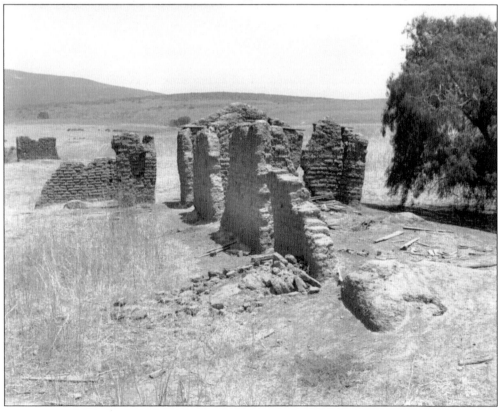

Californio men were often known for their horsemanship. Luis Abran Serrano (1846–1933) was a Californio stage driver with deep roots in early San Diego. Serrano and Frank Shaw drove Seeley's stages between San Diego and Los Angeles, meeting at San Luis Rey where the drivers saluted each other with cracks of their whips. (SDHC.)

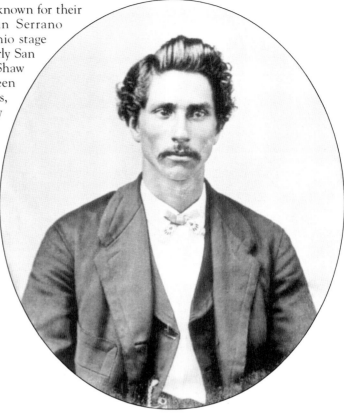

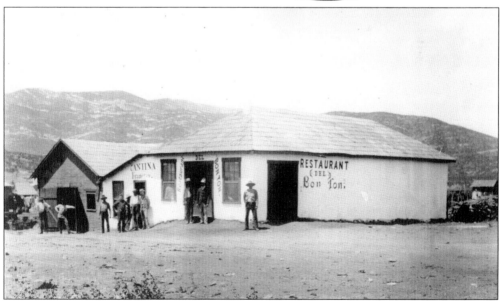

With a store, saloon, blacksmith shop, and lodging, San Luis Rey was on Seeley's route. By 1884, the stop was moved to Oceanside. Stage drivers faced many hazards, and drivers and stage contractors had to be flexible. The June 29, 1873, *San Diego Union* reported, "Mr. Seeley is making a good road across the sandy river bed with rubbish and sea grass." (ABC.)

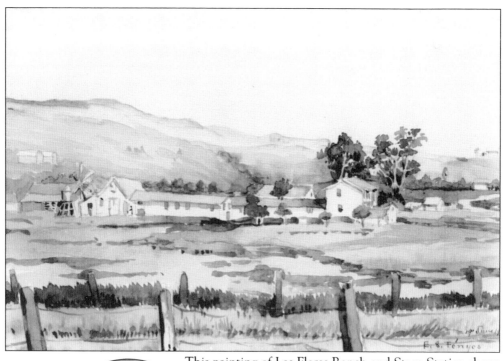

This painting of Las Flores Ranch and Stage Station shows the complex of buildings owned by Marcos Forster. In 1876, a northbound stage with two passengers attempted to cross the rising San Onofre Creek after leaving Las Flores. The lead horses became entangled by a large, floating tree limb. Those on board managed to swim ashore, but stage, baggage, mails, and two horses were swept out to sea. (SOHO.)

Frank Frary (1856–1911) worked for Albert Seeley and eventually drove Seeley's stage between San Luis Rey and San Diego. In 1882, he secured a government contract to carry the mail between San Diego and Julian. By 1885, Frary went into partnership with Joseph Foster as mail and stage operators. In his later years, Frary served as mayor of San Diego.

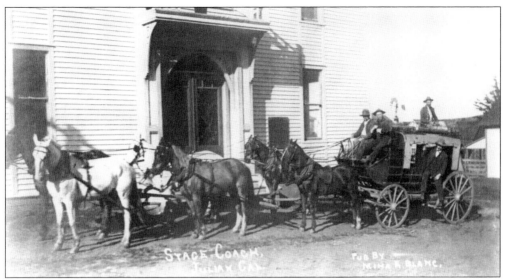

When gold was discovered in Julian and Banner, the area needed mail and stage service. Stages started running to Julian in the 1870s, and members of the Stokes family and William Tweed ran competing lines. Their rivalry escalated into a rate war. Later, the Julian City Stage Line operated by Frary and Foster carried passengers and packages triweekly to the mining area. The photograph shows a Julian stage. (SDHC.)

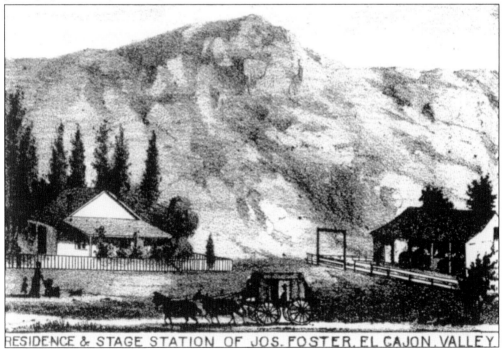

RESIDENCE & STAGE STATION OF JOS. FOSTER. EL CAJON VALLEY

Frary's partner Joseph Foster (1857–1933) came to San Diego in 1866. He drove the stage between San Diego and the mining town of Julian. Foster's home near Lakeside, in a farming community called Foster, served as a stage station and the terminus of the San Diego, Cuyamaca, and Eastern Railway. Like Frary, Foster was civic-minded and served on the San Diego County Board of Supervisors for 23 years.

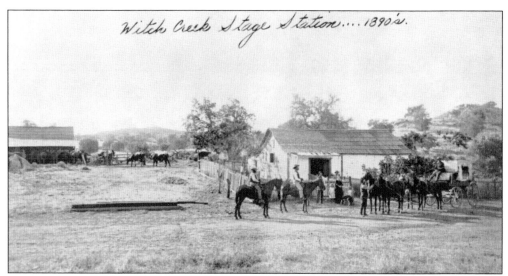

Witch Creek Stage Station..... 1890's.

This photograph shows the Witch Creek Stage Station with Foster's stage preparing to leave. The Witch Creek station was built in the early 1870s as a stop on the Julian–San Diego route. With the discovery of gold in Julian, the trail through Ballena and Witch Creek became busy with horse, wagon, and stage traffic. (SDHC.)

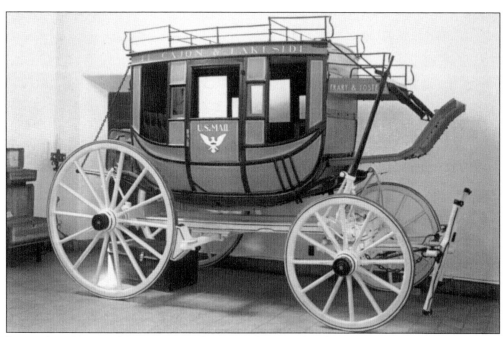

Pictured is a Frary and Foster Concord stagecoach. Completed in 1866, this coach was in Santa Barbara when Joseph Foster purchased it in 1886. Later, it was acquired by Thomas Getz for the Casa de Estudillo in Old Town. Then Arnold Babcock of Coronado gave it to the Pioneer Society. Restored in 1930 and again in 1961, it is now on display at the San Diego History Center.

This 1906 photograph taken by Albert W. Shattuck is captioned, "On the way home from Sunny Slope Mine." Shattuck and Ed Dolloff (left) tried tourmaline mining in Mason Valley and traveled by Julian stage on part of their route. They also stopped at the Witch Creek Hotel. The other stage passengers pictured are unidentified. (JAB.)

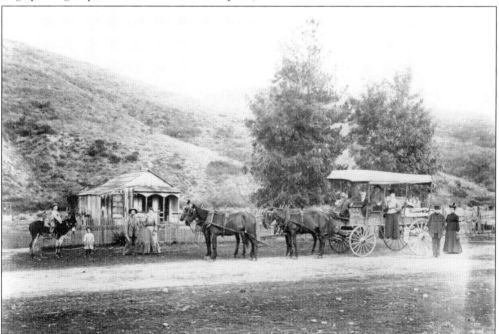

This photograph shows the halfway station at the foot of the Poway Grade on the San Diego and Escondido Stage Line. Members of the Reading family, who operated the meal stop and changed the horses, are shown. They are, from left to right on the left, James Jr., Edna, James, and Kathryn; the other people are unidentified. The Escondido stage had a female driver for many years, as did the Mesa Grande stage. (SDHC.)

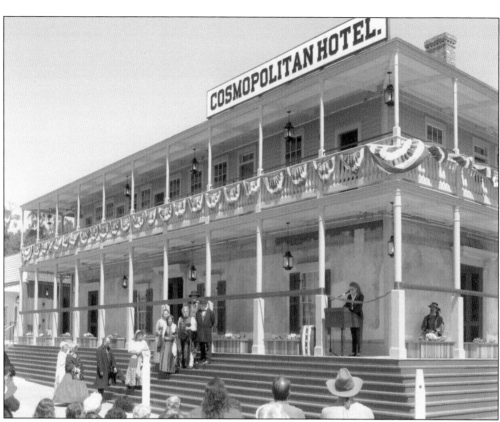

In 2010, California State Parks completed a restoration of Old Town's Cosmopolitan Hotel. Much original material was found in good condition from the Bandini and Seeley eras despite the building's interim use as an olive factory, hotel, and restaurant. The adobe lower level built by Juan Bandini in 1829 and the wood-framed second story added by Albert Seeley in 1869 were returned to their former appearance. (MMS.)

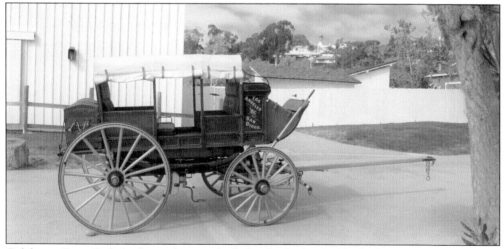

California State Parks had a mud wagon built for the Seeley Stable display. Seeley was proud of his stagecoaches and offered rides to the public when he received new equipment. One new coach was painted a brilliant yellow with gilt lettering. (MMS.)

Nine

PRESERVING THE PAST

People everywhere are drawn to the romance and excitement of stagecoaches. Many original journals, newspaper articles, and books have been written about stage travel. In San Diego County, three Birch and Butterfield stage stations remain: Vallecito, Warner-Carrillo, and Oak Grove. The original road can be seen in some desert areas and at Rancho Peñasquitos. Hand-hewn rocky passages can be viewed at Box Canyon. None of these would remain were it not for some extremely dedicated individuals who saw the importance of this history and worked diligently to preserve it.

Louis and Dolores Strahlmann of San Diego were responsible for alerting people to the importance of the San Antonio–San Diego Mail Line, for collecting an impressive collection of stage photographs, maps, and memorabilia, and for pulling together politicians, historians, archaeologists, and the public to preserve Vallecito Stage Station at a time when preservation was not popular. Their enthusiasm, professionalism, and organization cannot be matched. Members of the Wilmington-based Phineas Banning family drove stagecoaches, managed stage lines—including some lines in San Diego County—and then wrote books and articles about the Butterfield route. At one time, they owned Catalina Island, operated it as a resort, and ran stages there. Capt. William Banning brought stagecoaches and horses to celebrations so people could experience what it was like to ride in these marvels.

Captain Banning shared his enthusiasm with artist Marjorie Reed. Her paintings capture the romanticism of stagecoaches and help people visualize stage travel. She painted many images of Butterfield stage stations and published four books of her paintings.

Today, the preservation effort is a combination of activities by owners of the stage stations, park staff, and volunteers. It takes many people to preserve information and buildings and then to present them to the public for enjoyment and pleasure. Popular interest in stagecoaches has not waned, and people still want to feel the excitement of horses, mules, and stages.

In the 1930s, travel was slow and cumbersome on unpaved backcountry roads. Camping did not include fancy motor homes but consisted of canvas tents as these photographs of Dolores (1890–1972) and Louis Strahlmann (1891–1952) show. The Strahlmanns were captivated by the San Antonio–San Diego Mail history. As pioneering preservationists, they organized volunteers, both amateur and professional, who shared their interest. Their goal was to restore the stage stations of San Diego County, to add artifacts of the era to museums, and to mark the historic roads. They had unceasing energy and were as concerned about historical accuracy as any professional historian. Starting in the late 1920s, they gathered oral histories from surviving stage drivers, corresponded with descendants of drivers and passengers, and combed libraries and museums. Unfortunately, they were only able to restore Vallecito Stage Station.

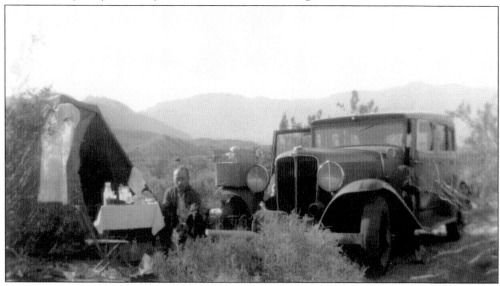

Dr. Louis Strahlmann (left), a police surgeon, and his uncle Max Mayer, with the family dog, explored many stage roads. This gave them a unique appreciation for the accomplishments of James Birch and his employees as well as an understanding of the experiences of stage passengers. Historical research not only involves searching through libraries and archives but also includes such practical experiences when possible.

Life for emigrants, stage passengers, and stage station superintendents was dangerous. Many people died of disease, exposure, thirst, or were murdered. Records and journals note the deaths of many different people along the stage routes. The Strahlmanns worked to preserve the graves they found. On one occasion, Dolores Strahlmann broke her foot when she dropped a rock on it while restoring a grave site.

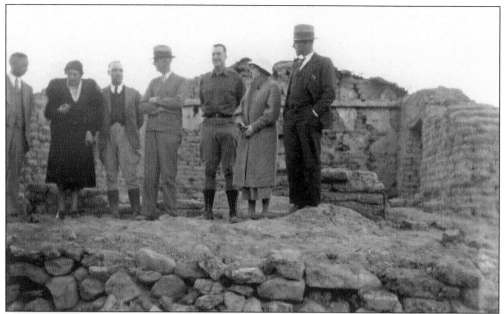

Members of the El Centro Chamber of Commerce pose in front of the ruins of the Vallecito Stage Station in early 1934. The Strahlmanns invited them to participate in the preservation of the stage stations and stage roads with an emphasis on tourism benefits. Dr. and Mrs. Strahlmann understood that protection and maintenance of important stage stations required political involvement.

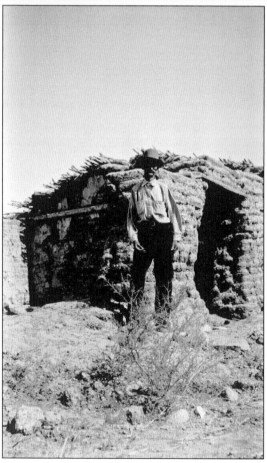

Andrew Jackson Elliott (1859–1942), pictured here in 1934, was a Pony Express rider in the late 1870s. Familiar with all desert roads between Yuma and San Diego, he was invited to speak to a gathering at Vallecito about the history of that era. Gathering information from people who experienced events is an important part of preservation efforts.

Another family involved in preservation of the stage routes was the Banning clan. Phineas Banning (1830–1885) drove a stage in the Los Angeles area, ran a stage line from the gold country south, and eventually drove stages from Los Angeles to Fort Yuma. In 1929, his grandson George Hugh Banning (1895–1989) drove this car on the Butterfield stage route through Texas, New Mexico, Arizona, and California.

On his travels, George H. Banning photographed each stage stop whether or not there was a building remaining. He took notes on travel time, the area surrounding the stop, and any historic information. This photograph is an example of his detail. George and his uncle William Banning wrote *Six Horses*, the definitive book on the stagecoach history of California.

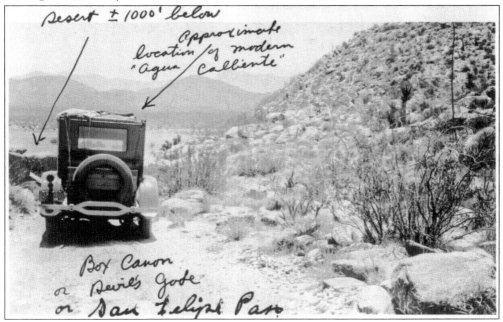

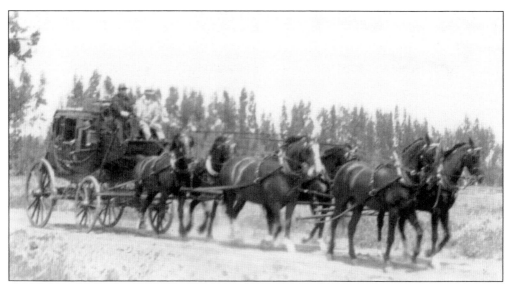

Capt. William Banning (1858–1946), the eldest son of Phineas Banning, drives his Concord stage with six horses in this 1928 photograph. William had a collection of priceless family stagecoaches. He took this stage to fairs, festivals, and celebrations to show people what stage history was about.

WILLIAM BANNING
WALNUT
LOS ANGELES COUNTY, CALIF.

Dec 28th 1940

Dear Mrs Strahlmann

Please accept many thanks for the Christmas remembrance. In looking over old negatives last week I found the negative from which this print was taken and I thought you might like to add the print to your collection, It shows up the team to advantage. With kind regards to you and doctor Strahlmann I am Sincerely Yours

William Banning

Dolores Strahlmann and William Banning corresponded regarding the historic stage routes. Dolores was an avid researcher and gathered maps, photographs, letters, journals, artifacts, and antiques for the stage station museums. Vallecito stage station was restored in 1934 and 1935. Captain Banning planned to bring his stagecoach and horses to the Vallecito dedication, but plans were continually delayed in the hopes of also having the stable rebuilt.

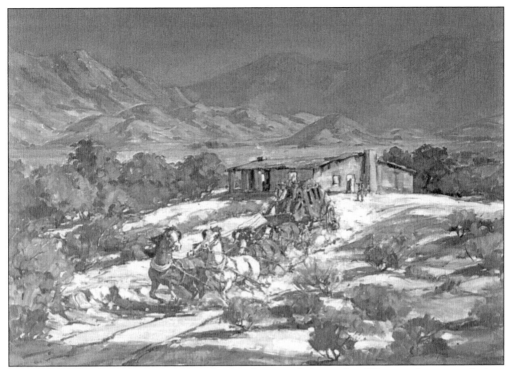

Marjorie Reed (1915–1996) was a major artist whose work focused on Western themes, including the Butterfield Stage stations. While traveling the country in the early 1930s, she met Capt. William Banning. He told her stories of the Overland Mail and let her ride in his stage; she became enthralled with the subject. In 1938, she met Everett Campbell and spent some time at his ranch near the restored Vallecito Stage Station. From the late 1930s to late 1940s, Reed traveled the stage route of the Butterfield Overland Mail and made sketches for her oil paintings. The painting above is one of many she did of Vallecito, and the one below shows the Carrillo station at Warner-Carrillo Ranch. Reed even lived for a short time at Oak Grove Stage Station. She died at the old Campbell Ranch in Vallecito. (Below, ABC.)

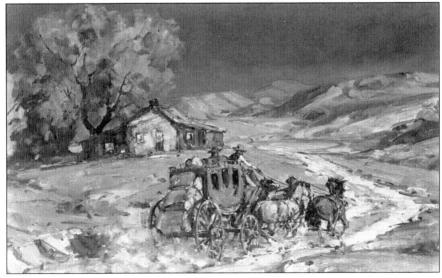

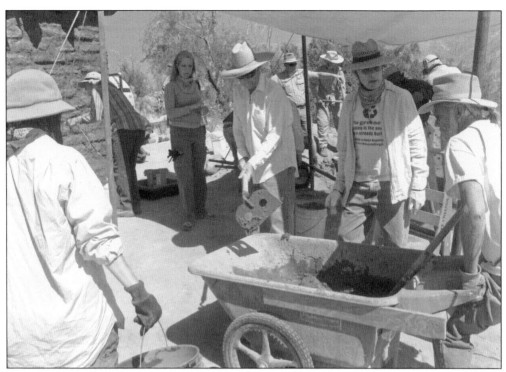

Once buildings have been restored, routine, historically accurate upkeep, maintenance, and preservation must be done. These photographs show staff and volunteers from the County of San Diego Department of Parks and Recreation, California State Parks, and Save Our Heritage Organisation (SOHO) working on the preservation of Vallecito Stage Station. This sod building has lasted for over 150 years with two restorations. The event pictured is an educational session showing people how to apply adobe mud plaster to the sod walls to keep them from deteriorating. These types of preservation efforts are cost-effective in safeguarding historically important buildings for future enjoyment. (Both, MMS.)

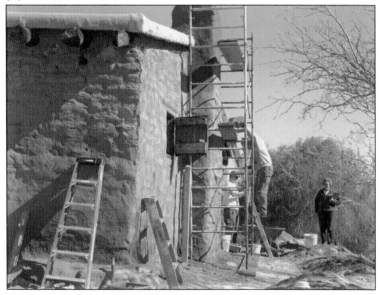

Ten

RESTORATION OF
VALLECITO STAGE STATION

The restoration of Vallecito Stage Station was the dream of Louis and Dolores Strahlmann. They were leaders of a group of San Diegans who wanted to preserve the deteriorating stage station and to commemorate the San Antonio–San Diego Mail Line and planned a series of monuments and stage station restorations. Unfortunately, the Vallecito restoration was the only part of this goal to be completed.

To generate interest in their project, the Strahlmanns organized visits to Vallecito in early 1934 and convinced many people to donate time, labor, services, and supplies. They contacted the owner of the property, Judge Christopher F. Holland, and convinced him of the worthiness of their project. Holland deeded land consisting of the stage station, the cemetery, and a nearby spring to the County of San Diego. John Siebert contributed his services as architect, archaeologist Malcolm Rogers served as consultant, and Fred Grand did the woodwork. Granville Martin and neighbor Lena Campbell made the rawhide strips to tie the roof tules. Everett Campbell, who had been trying to protect the property from vandals, supervised the construction, and John Snyder searched for old photographs. Beyond Vallecito, the stage route continued through Imperial County. The El Centro Chamber of Commerce and the Imperial Highway Association participated in the project, and the groups hoped to one day restore Carrizo Creek Station.

The involvement of several government entities was invaluable. The federal government provided assistance to put people to work during the Depression. The crew that restored Vallecito Stage Station was part of this program. The San Diego County Board of Supervisors provided support. The Strahlmanns also contacted Guy Fleming, superintendent of the Southern Division of California State Parks, for assistance with timbers from Cuyamaca Rancho State Park.

The County of San Diego followed part of the original plan and developed a camping park. Now, each year at Vallecito Days, another group of dedicated volunteers and historians tells the history of the stage route and the story of the people who lived at Vallecito. The Strahlmanns and their group of devoted and enthusiastic helpers would be proud.

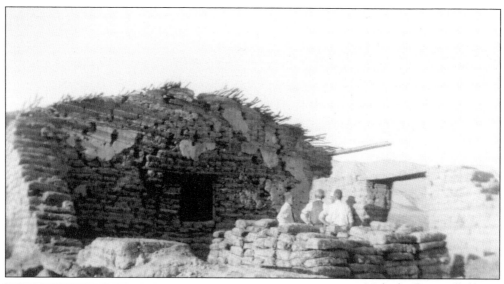

Malcolm Rogers (left), John Seibert (center), and Dr. Louis Strahlmann sit in Vallecito's large fireplace room to inspect the building and to discuss the restoration in 1934. This room and the middle room were built by the Lassator and Mulkins family in 1856. Dolores Strahlmann acted as photographer during the restoration and kept very good notes about all aspects of the construction.

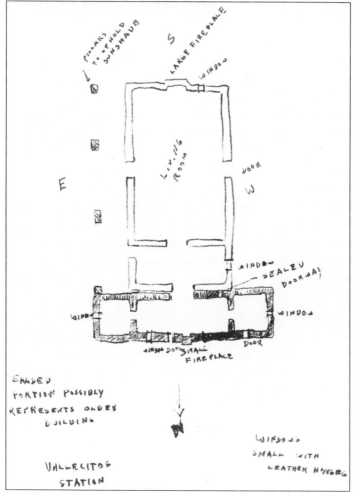

This rough sketch was made in 1931 by Arthur Woodward, curator of history at the Los Angeles County Museum, in preparation for making a diorama of Vallecito for museum display. As one of the experts consulted by the Strahlmanns, he provided input on road systems and architectural elements.

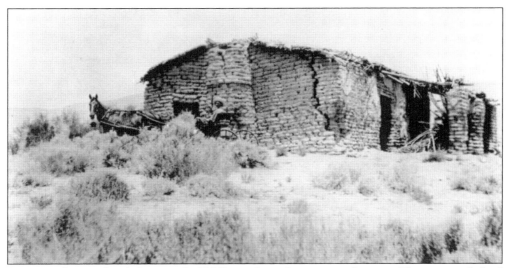

Many people visited and photographed Vallecito Stage Station over the years. These images helped to document the building's deterioration. Virginia Wilhite rode to the station in 1918, and she sent the photograph to Dolores Strahlmann in 1934. Not only did the Strahlmanns restore the station, but they also gathered artifacts, antiques, photographs, and miscellaneous items relating to stagecoach days—all planned for a Vallecito museum.

Wooden sawbuck packsaddles like this one were placed on mules to hold the mail sacks and various other packages and equipment. Three of these packsaddles, destined for a museum at Vallecito, are found in the Strahlmann Collection, County of San Diego Department of Parks and Recreation. (MMS.)

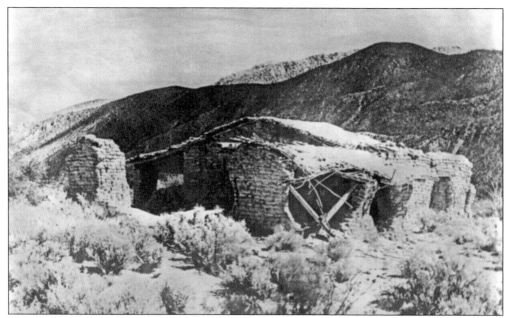

This photograph, showing the station's north side, was taken by Willard Wood about 1924. It was among the items collected by the Strahlmanns. Most of the exterior and dividing walls are gone. Note the sod building corner to the left indicating a separate structure, possibly the place where the Butterfield Stage station managers lived.

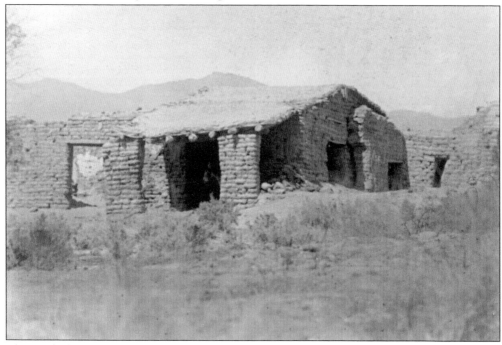

The east side of the stage station, where the columns are located, is shown in this photograph. Note the donkey seeking shade under the veranda. Based on their research, the Strahlmanns believed that the original building was the northern three rooms, built about 1854 by James Ruler Lassator and his stepsons.

In 1888, Christopher Franklin Holland bought 160 acres of Vallecito Valley, which included the stage station, from James E. Mason. Holland, a Los Angeles attorney, still kept ties to his land. Following his land donation for a park, Holland fought to preserve the building and to have the park established as originally proposed. His untimely death in 1938 precluded his dream of eventually living in the valley.

James E. Mason obtained the first patent to the land, even though others had lived on it. After the property sale, Holland and James E. Mason remained close friends. Mason eventually moved to the next valley to the north, which now bears his name. (SDHC.)

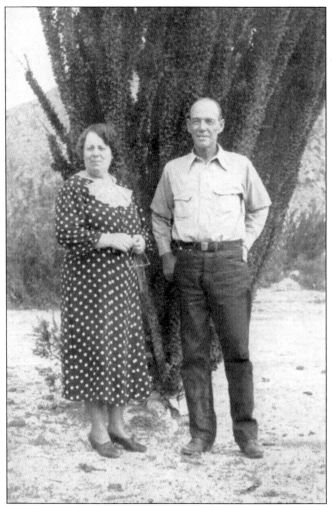

Another couple devoted to Vallecito and the restoration was Everett and Lena (McCain) Campbell. Beginning in 1916, they owned a cattle ranch near Vallecito. They were saddened by the destruction and deterioration they saw and so saved the original massive hand-hewn ridgepole by removing it to their ranch. Everett was so devoted to the history of the Vallecito area that he agreed to be the construction superintendent.

Architect John Seibert saw the potential benefit of the Vallecito Stage Station restoration. This drawing shows his original plan, which caught the imagination of the public and San Diego County officials. Drawing labels are (1) old stage station; (2) old stable; (3) caretaker's home; (4) well and watering trough; (5) graveyard; (6) cactus plantings; (7) auto parking space; (8) campground; (9) Butterfield stage road; and (10) new road.

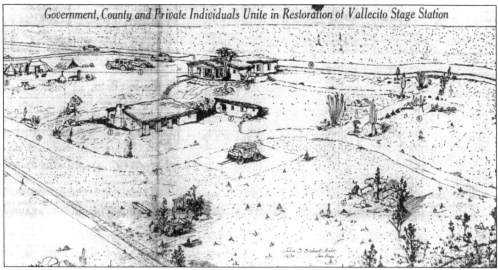

Government, County and Private Individuals Unite in Restoration of Vallecito Stage Station

Dolores Strahlmann's note shows that the Vallecito restoration was part of the Works Progress Administration (WPA). During the Depression, the WPA was established to generate public jobs for the unemployed. Through the Federal Emergency Relief Administration (FERA), California established the State Emergency Relief Administration (SERA) in 1933. FERA provided money for wages and salaries, while the project sponsors provided materials, supervision, and transportation.

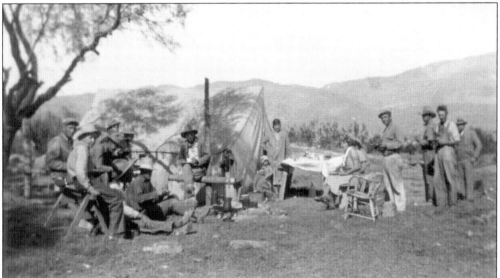

Projects chosen for SERA work were those that would make a real and lasting contribution. In this photograph, SERA workers prepare their camp near the dilapidated stage station in July 1934. In October 1934, their part of the project was completed thanks to the hard work of these men and women during the hottest part of the summer, where temperatures could reach 115 degrees.

This note, found tucked in a *Butterfield Chronicle* magazine, documented the number of sod bricks and the area of the building restored. The note states that 12,710 sod bricks (16 by 20 by 4 inches) were used and 3,713 cubic feet were built. Also, 1,920 square feet of roofing was laid by the SERA workers.

Dolores Strahlmann wrote about this photograph, "SERA boys working on restoration. We call them 'The Vallecito Nudy Colony.' Being in the Colorado Desert it is very hot." Here, they are mixing mortar.

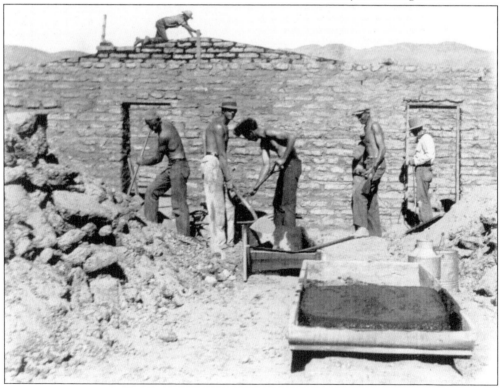

Vallecito Stage Station is made of sod, not adobe, and is one of the few sod buildings in California. The sod was taken from the extensive grasslands located around various springs south of the building. Sod for the original construction, as well as the restoration, was taken from the same *ciénega* (marsh). Using a plow and machete, a man could cut 90 blocks of sod a day.

Long before the National Historic Preservation Act of 1966 guidelines were established, the Strahlmanns, Campbells, and Seibert restored Vallecito using methods that would someday become the norm. Part of the guidelines states, "Where the severity of deterioration requires replacement of a distinctive feature, the new feature will match the old in design, color, texture, and, where possible, materials." The 1934 sod blocks were a "distinctive feature."

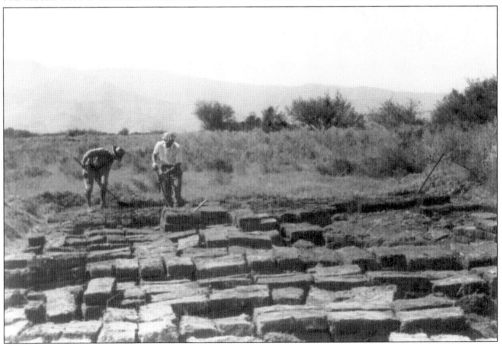

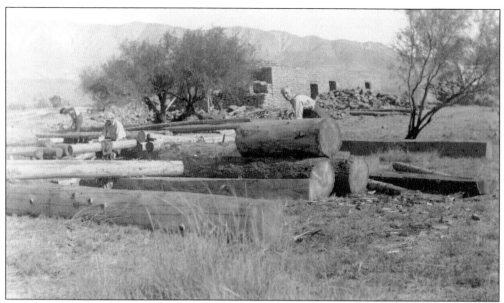

Timbers from Cuyamaca
were brought to Vallecito,
where they were hand hewn
as was done in the 1850s;
the trees used were pine and
incense cedars. Permission
was granted by Guy Fleming,
southern superintendent
for California State Parks.

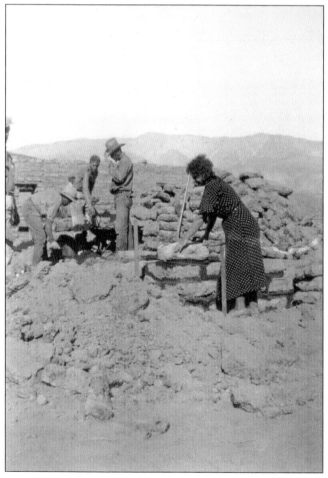

As the men of SERA worked
under the supervision of
Everett Campbell, Dolores
Strahlmann laid the
cornerstone. The Strahlmanns
spent years planning,
publicizing, researching,
contacting stage family
descendants, collecting items
for a museum, promoting,
working with governmental
agencies, and being the
driving force behind the
dream for recognition of the
San Antonio–San Diego Mail.

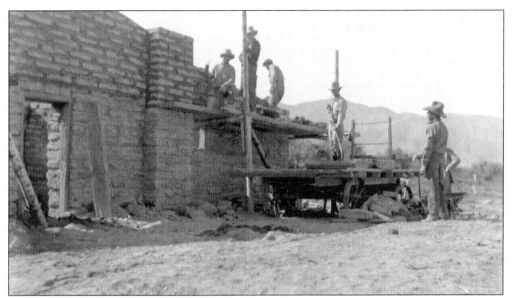

With the guidance of Everett Campbell, hardworking men used wooden scaffolding to build the north wall. The iron-wheeled wagon was used to provide sod and mortar to the workmen. The county supplied much of the tools and equipment.

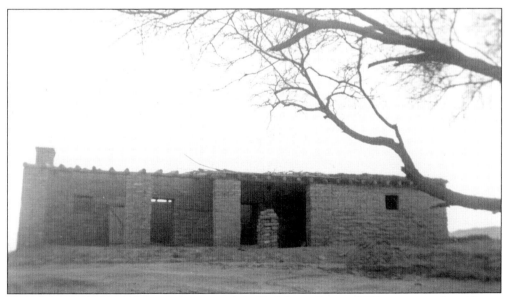

This photograph shows the stage station with half of the roof started. Three massive hand-hewn beams held up the roof in the original building. Everett Campbell saved one by removing it to his ranch. During the restoration, he put it back. The second beam was saved in place, while only one was made new. The old rafters were replaced.

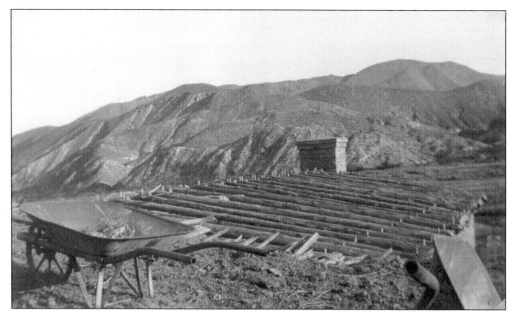

Old and new willows were used and tied to the rafters. Five rooms originally had cow rawhide ties, and new strips were supplied by Granville Martin, George Sawday, and Everett Campbell. One room had deer rawhide ties supplied by Lena Campbell from five deer-hide rugs. The final layer was sod. In later years, the county replaced the roof when maintenance of the sod became too difficult.

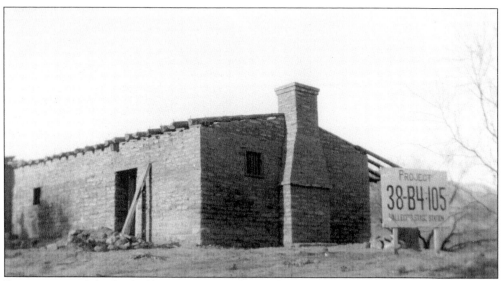

Everyone wanted the finished product to be as close to the original as possible. Floors in the building were left as dirt floors. Originally, no nails were available, so builders used wood pegs; Campbell did the same in the restoration. All doors and windows were hewn from logs, as were the originals. Door hinges, latches, and other hardware were made in a forge in the blacksmith shop.

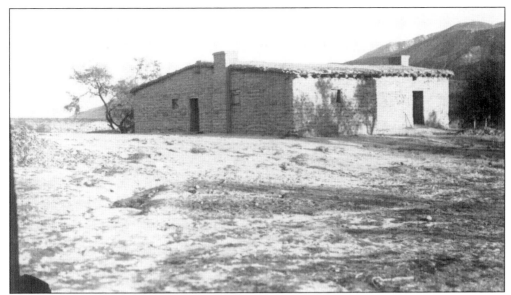

This photograph taken by Dolores Strahlmann shows the Vallecito Stage Station in 1935 after the bulk of the restoration work had been completed. Vallecito Stage Station is a tribute to people past and present, those emigrants, stage drivers, passengers, soldiers, ranchers, and their families, as well as the volunteers who kept it in good condition.

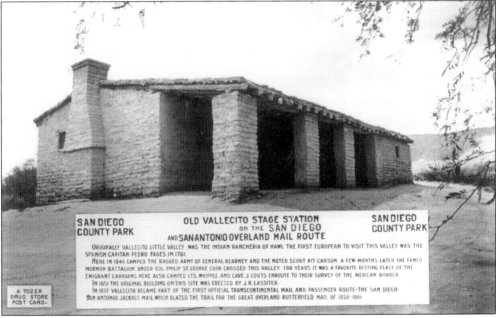

SAN DIEGO COUNTY PARK OLD VALLECITO STAGE STATION
ON THE SAN DIEGO
AND SAN ANTONIO OVERLAND MAIL ROUTE SAN DIEGO COUNTY PARK

ORIGINALLY VALLECITO LITTLE VALLEY WAS THE INDIAN RANCHERIA OF HAWI. THE FIRST EUROPEAN TO VISIT THIS VALLEY WAS THE SPANISH CAPITAN PEDRO FAGES IN 1781.
HERE IN 1846 CAMPED THE RAGGED ARMY OF GENERAL KEARNEY AND THE NOTED SCOUT KIT CARSON. A FEW MONTHS LATER THE FAMED MORMON BATTALION UNDER COL. PHILIP ST GEORGE COOK CROSSED THIS VALLEY. FOR YEARS IT WAS A FAVORITE RESTING PLACE OF THE EMIGRANT CARAVANS. HERE ALSO CAMPED LTS. WHIPPLE AND CAVE J. COUTS ENROUTE TO THEIR SURVEY OF THE MEXICAN BORDER
IN 1851 THE ORIGINAL BUILDING ON THIS SITE WAS ERECTED BY J. R. LASSITER.
IN 1857 VALLECITO BECAME PART OF THE FIRST OFFICIAL TRANSCONTINENTAL MAIL AND PASSENGER ROUTE-THE SAN DIEGO-SAN ANTONIO JACKASS MAIL WHICH BLAZED THE TRAIL FOR THE GREAT OVERLAND BUTTERFIELD MAIL OF 1858-1861

A TOZER DRUG STORE POST CARD.

This postcard of Vallecito Stage Station, with a copy of the sign that stood for years outside the building, reminds people of the difficulties and struggles of life in the 1850s and 1860s. A trip to the San Diego County backcountry to see the old stage station, remembering the remarkable story of its restoration in 1934, is definitely worth the trip.

Discover Thousands of Local History Books Featuring Millions of Vintage Images

Arcadia Publishing, the leading local history publisher in the United States, is committed to making history accessible and meaningful through publishing books that celebrate and preserve the heritage of America's people and places.

Find more books like this at
www.arcadiapublishing.com

Search for your hometown history, your old stomping grounds, and even your favorite sports team.